GLOUCESTER
From Old Photographs

Images by John Rowden

PHILIP MOSS & DERRICK HALL

AMBERLEY

John Rowden 1924–2016

First published 2016

Amberley Publishing
The Hill, Stroud
Gloucestershire, GL5 4EP

www.amberley-books.com

British Library Cataloguing in Publication Data.

A catalogue record for this book is available from the British Library.

ISBN 978 1 4456 6220 6 (print)
ISBN 978 1 4456 6221 3 (ebook)

Origination by Amberley Publishing.
Printed in the UK.

Contents

Acknowledgements

Very grateful thanks are due to Louise Rowden for making her father's photographs available and for providing valuable information about them for this book.

Thanks are also due to Hugh Conway-Jones and Debbie Hotchkins for their helpful comments on certain photographs.

Most of the information in this book has emanated from the writers' memories. Often the specific dates regarding events and the disappearance of certain buildings eluded us. We gratefully acknowledge the use of the Gloucester volume of the *Victoria County History, The Picture Palaces of Gloucester & Cheltenham* by Alan Moore, *The Story of Gloucester's Pubs* by Darrel Kirby, and various street directories.

Introduction

Most of the photographs in this remarkable collection were taken between 1955 and 1965 at a time when the City of Gloucester was about to undergo a period of profound change. Through a series of redevelopments and refurbishments parts of the city have since been altered beyond recognition but their passing has been recorded here.

The majority of these photographs by John Rowden were taken on Sunday mornings in order to avoid the street scenes being cluttered with shoppers. John regularly travelled into the city centre from his home in Hempsted Lane carrying his trusty 35 mm. Leica camera in a Second World War gas mask case. He initially cycled into town, later he travelled there by Lambretta scooter that was then replaced by a Morris Minor car. All three modes of transport can be glimpsed in various photographs that helped to sort the date order of some of the pictures.

Among the views are a number of quiet corners of the city that had previously been ignored by other photographers. A now vanished way of life has been recorded here and the reader will notice forests of television aerials, a distinct lack of parked cars, policemen on the beat, gentlemen cyclists on their way to their favourite lunchtime hostelries and skeins of telephone wires.

All the images were captured on black and white slides that John occasionally showed to local clubs and societies who were fortunate enough to see them. It is therefore a pleasure to make these photographs available to a wider audience in memory of our friend John Rowden.

Philip Moss and Derrick Hall

Alvin Street

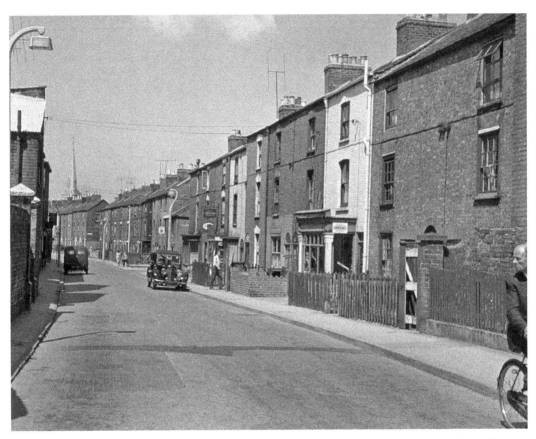

Alvin Street was first recorded in the early thirteenth century when it was known as Fete Lane. The lane ran from London Road to the Alvin Gate at the northern end of Hare Lane that, at that time, was the main road into Gloucester from the north.

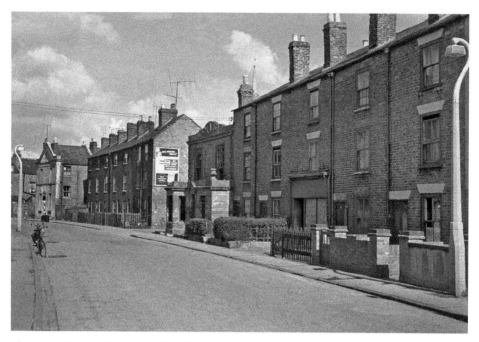

The rows of terraced houses in Alvin Street, together with those in Sherborne and Oxford streets, were built in the 1820s. The entrance to Columbia Street that was built in 1831 can be seen in the centre of the photograph.

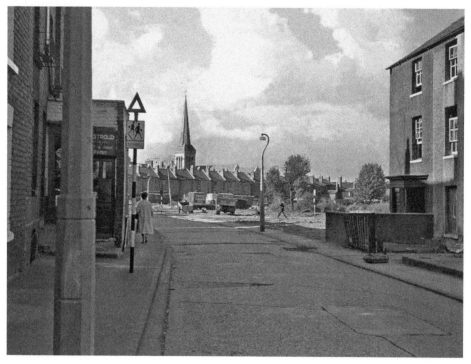

The area to the northeast of Alvin Street was almost totally cleared for the building of new housing that included the eleven-storey Clapham Court completed in 1963.

The Barracks

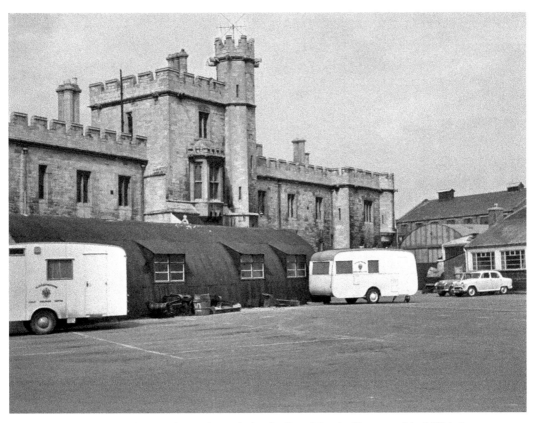

The Barracks were built in the Gothic style for the Royal South Gloucestershire Militia between 1854 and 1856 and were taken down in the early 1960s for extensions to the Shire Hall. The caravans belonged to the County Child Welfare department and the single-storey building on the right housed the County Surveyor's Road Design Office.

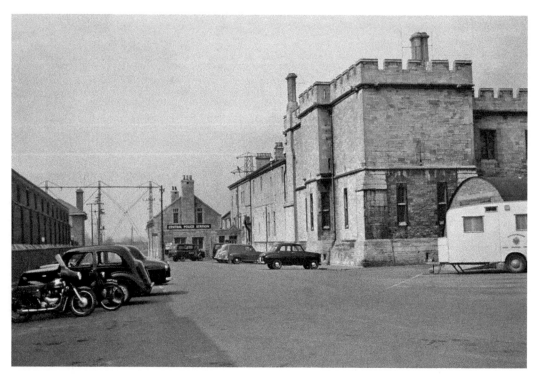

Barrack Square looking towards the river with the electricity pylons on Alney Island in the distance. The central police station relocated here from Marybone House in Bearland prior to moving to new facilities in the Shire Hall tower block. The Gloucestershire School of Domestic Science moved from its original site in Quay Street to the Barracks in 1894. In 1958 it relocated to new premises at Oxstalls.

Barton Street

The original name derives from the bartons or farms and enclosures belonging to Gloucester Abbey and the Crown on land on either side of the roadway just outside the east gate of the town. In the 1980s the upper part of the street was renamed Eastgate Street in a misguided attempt to upgrade the area. The famous Barton Fair was held here from 1465 when the abbot of Gloucester was granted the right to hold a three-day fair on the feast of St Lambert in September. Over the centuries it was variously used as a mop or hiring fair and for the sale of pigs, sheep and cheese. The livestock elements were removed to the new cattle market in 1823 and the fair continued as a mainly amusement attraction that was relocated to the Oxlease in 1904.

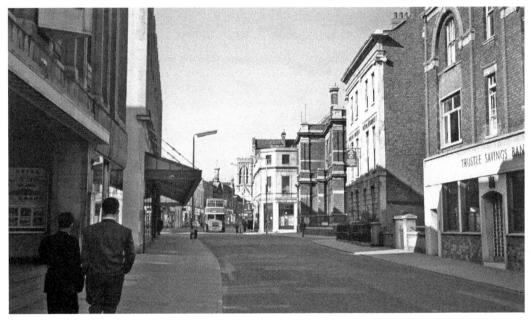

On the left is the Odeon Cinema opened in 1935 as the Plaza by the Eltron Cinema Company. The name changed in 1957 when the company was taken over by the Rank Organisation who later converted it into a Top Rank Bingo Club in 1975. The building immediately to the right of St Michael's tower is Thomas Cook & Son travel agents. Immediately to the right is a Victorian brick building housing the offices and showrooms of the South Western Gas Board. This building replaced the home of William Ashmeade who developed the Ashmeade's Kernel apple in his garden here in the eighteenth century.

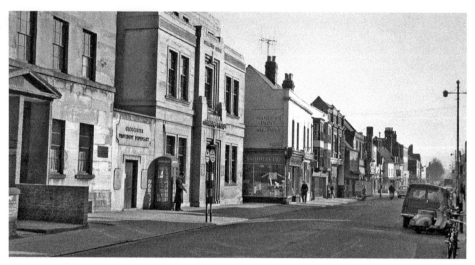

The Gloucester Dispensary was reorganised in 1872 as a provident society funded by members' subscriptions and donations. It later became a corporation health centre and closed in 1963. Beyond the Holloway Society building is the entrance to Clarence Terrace, originally a row of nine houses, but now a pedestrian walkway through to Russell Street. A little further on is T. G. Hall's old-fashioned cycle shop, fondly remembered by many as the hub of the Gloucester City Cycling Club. A policeman on the beat is a rare sight today and the one standing by the telephone box is probably waiting to call in. In the days before personal radios, officers kept in touch with the main police station at prearranged times at various phone boxes on his beat.

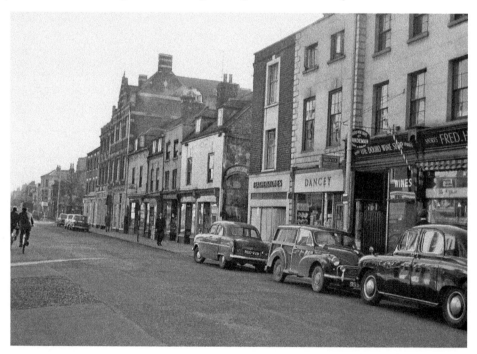

South side of Barton Street. From the extreme right, Fred Harvey's fishing tackle shop, The Douro Wine shop, Dancey's newsagents and Featherstones, bakers and confectioners. The latter proved very popular with the pupils at Sir Thomas Rich's School whose entrance was just next door.

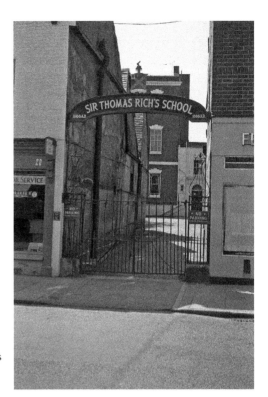

Most of the area to the south of this part of
Barton Street was occupied by Sir Thomas Rich's
School. The building beyond the entrance gates
housed the staffroom and Headmaster's study.

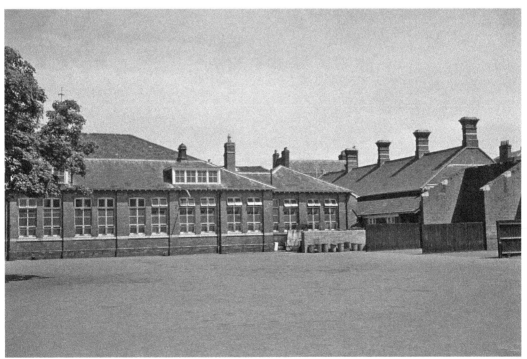

The Chemistry and Physics laboratories were housed in the building behind the tree with the assembly
hall to the rear. The roofless building with projecting wooden fences was used as a Fives court.

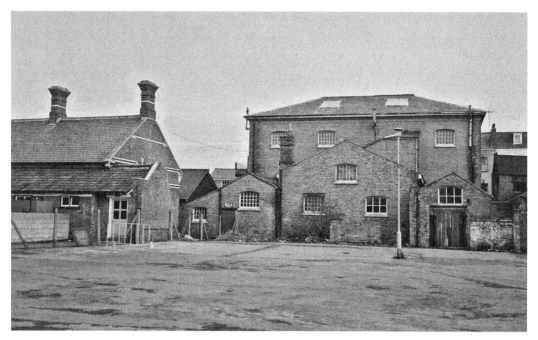

The larger of the buildings was used as a woodwork shop with classrooms on the upper floor. Most of this area was used for the creation of the Hampden Way car parks when Sir Thomas Rich's School relocated to new premises at Elmbridge in 1964.

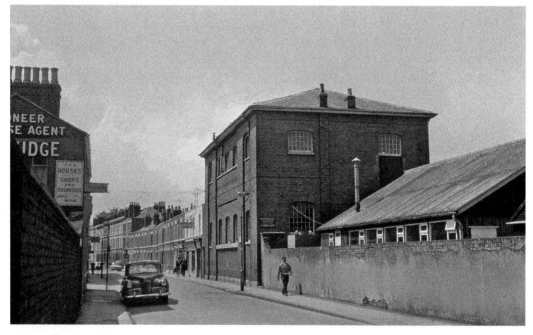

The small terraced houses in Wellington Street are dwarfed by the mass of the British School that opened in 1841. It was originally a mixed school accommodating over 300 pupils. It was renamed the Wellington Street Council School in 1905 and finally closed in 1931. The building was used by Sir Thomas Rich's School and later by the Workers Educational Association.

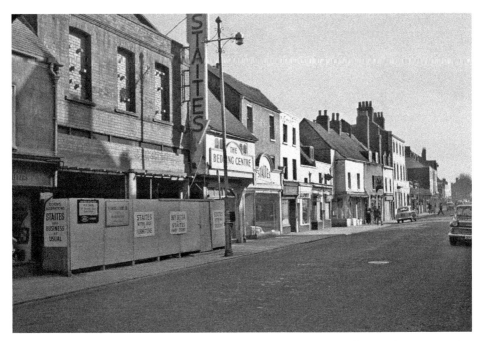

Nos 31–35 Barton Street was occupied by Staites furniture store, seen here undergoing a major rebuilding project. A little further on can be seen the hanging sign for the Crown and Thistle pub that first opened around 1830.

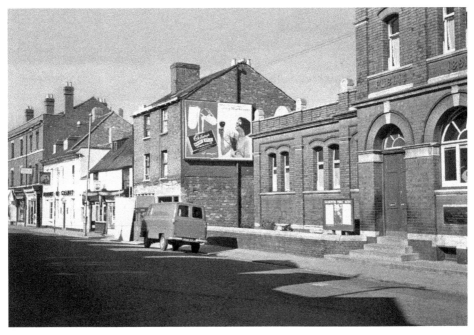

The Gloucester Public Baths opened in July 1891. It contained two swimming baths, first and second class, fourteen private baths, plus Turkish baths that were said to be the best of their kind in the west of England. Further to the left is The Marquis of Granby Inn that opened in 1820 and closed in 1957.

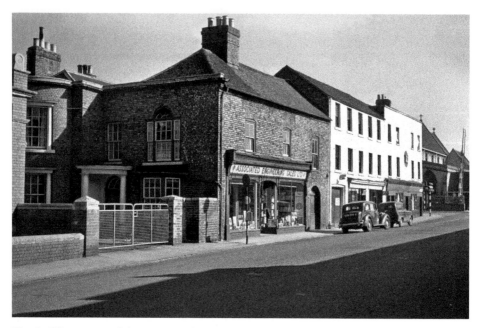

The building occupied by Associated Engineering Sales Ltd was Charlton House, which in 1912 was used as a training home for girls run by the Waifs and Strays Society. This house was demolished, together with the other buildings towards Barton Gates, to make way for a new swimming pool. The last building in the row was for many years used by the local Naval Club.

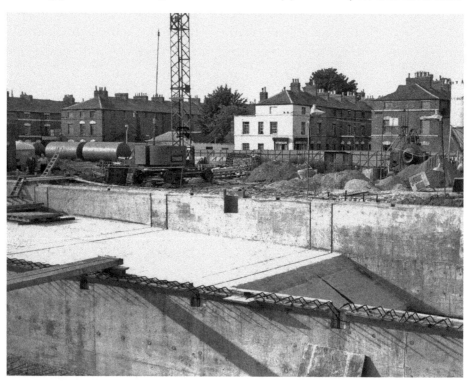

Construction work under way on the deep end of the new swimming pool that opened in 1966.

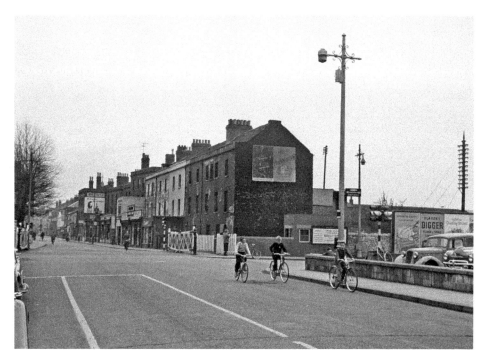

Barton Gates. This level crossing on the Tuffley loop line, opened by the Midland Railway in 1854, was a major cause of traffic congestion during weekdays until the line was closed in 1975.

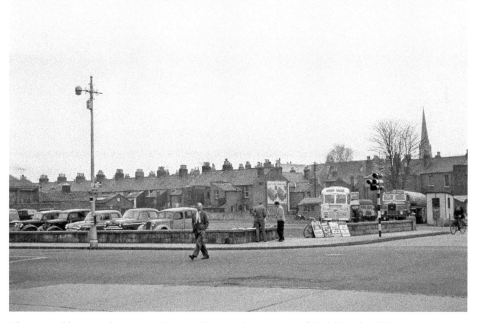

The car and lorry park opposite Barton Gates at the junction of Park Road and Barton Street was known as Wildman's Ground. On Sunday mornings the surrounding wall was used as a counter for the sale of newspapers and magazines. The site is now occupied by the Salvation Army citadel built in 1960.

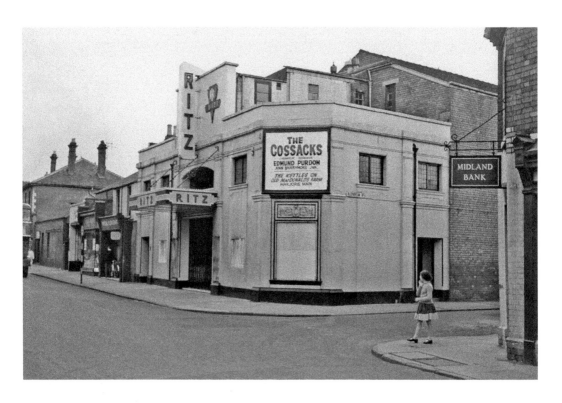

The Ritz Cinema was built by the Gloucester Cinema Company and opened in 1923 under the name of The Picturedrome. It was renamed the Ritz in 1955 and finally closed as a cinema in 1962 and reopened as the Alpha Bingo Club. The property was purchased by the Gloucester Operatic and Dramatic society in the early 1980s and occupied by them for many years.

Bell Lane

The lane was known as Travel Lane in the twelfth century and continued as such until the sixteenth century when it became known as Bellman's Lane following the establishment of William Henshawe's bell foundry between Eastgate Street and the lane. The line of the street is marked by the present Bell Walk in the Eastgate Shopping Centre.

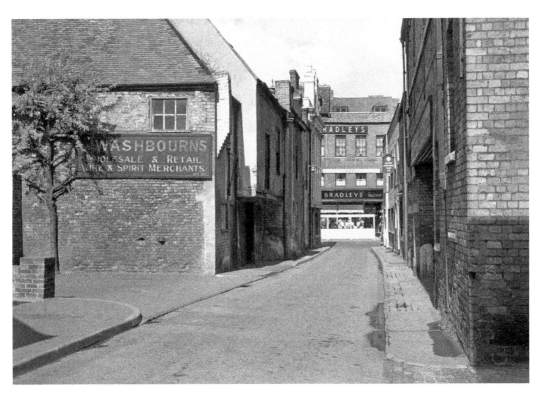

At the western end of Bell Lane is the entrance to Washbourns the wine and spirit retailers. Opposite is the entrance to the Bell Hotel Garage operated for many years by Hough & Whitmore Ltd.

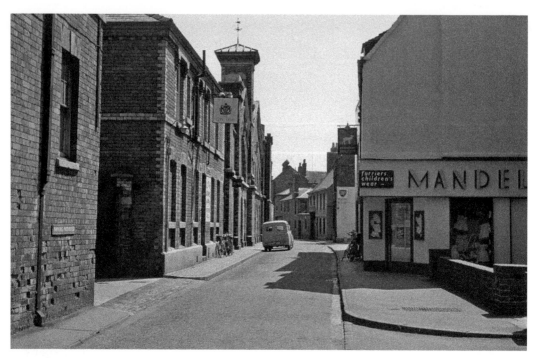

The lane viewed from Southgate Street. Prominent is the bell tower above the rear entrance to the Eastgate Market. The City Arms pub and the White Hart opposite obviously catered for thirsty cyclists on Sunday mornings.

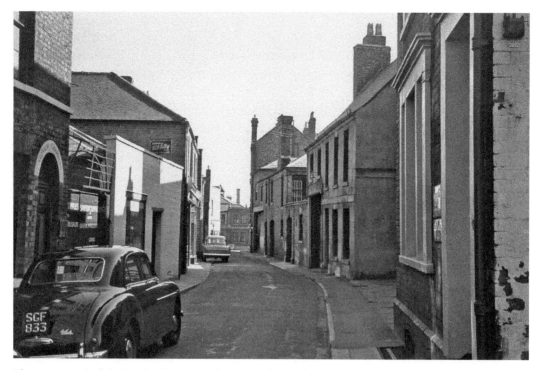

The eastern end of the lane looking towards Brunswick Road.

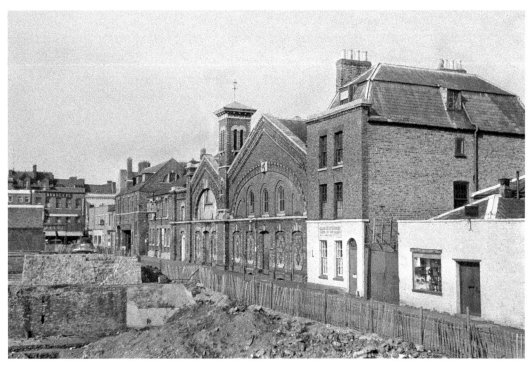

Demolition of the south side of the lane opened up a new view of the Eastgate Market.

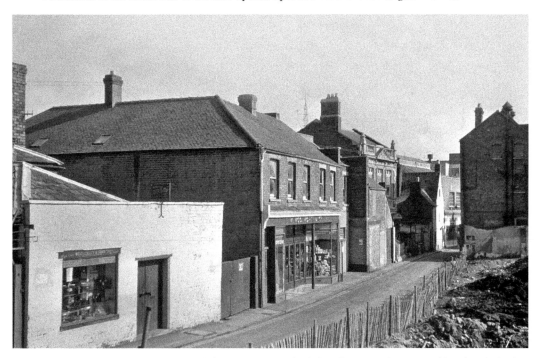

W. E. G. Colley & Sons occupied the building on the left selling a wide range of handmade leather goods. Next door was the rear entrance to F. W. Woolworths whose main entrance was in Eastgate Street. Beyond is the façade of Victoria Chambers.

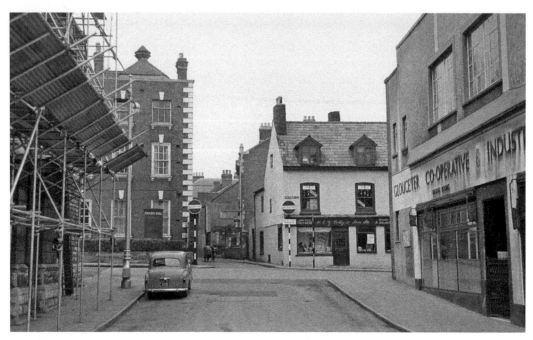

The entrance to Bell Lane from Brunswick Road with the City Museum shrouded in scaffolding on the left with Constitution House beyond. On the corner of Queen Street, now Queen's Walk, is Colley's shoe shop.

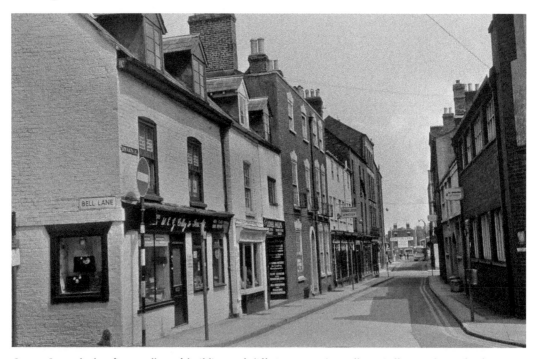

Queen Street had a fine medley of buildings of differing ages. As well as Colley's it housed other well-known local traders such as Lionel Phelps, fishing tackle dealer and the jewellery business of Donald Judd.

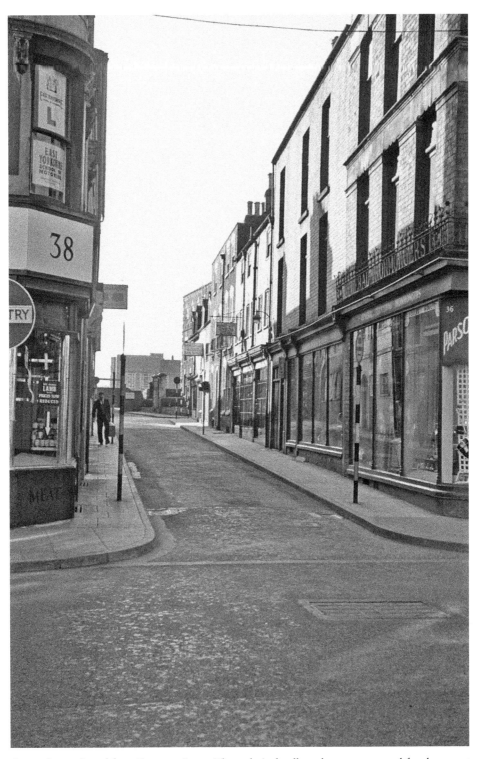

Queen Street viewed from Eastgate Street. The technical college that was removed for the recent Greyfriars housing scheme can be seen in the far distance.

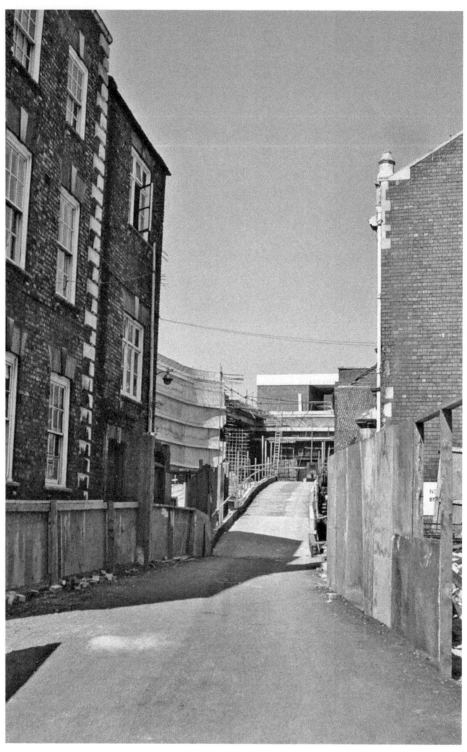

The development of Bell Lane is under way with the construction of the ramp to the goods delivery area and rooftop car park of the Eastgate Shopping Centre.

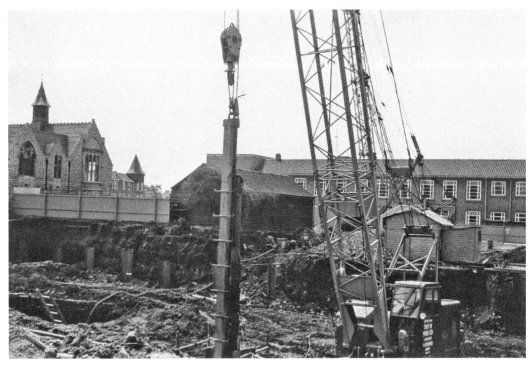

Construction work well under way on the New Market Hall foundations.

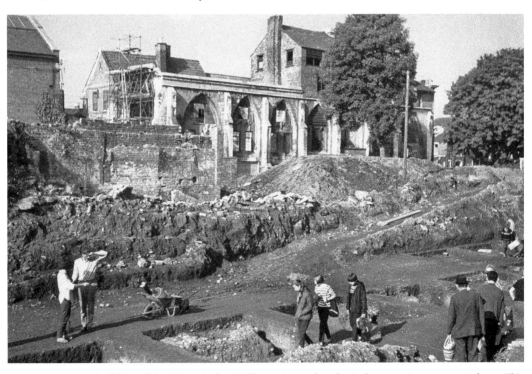

Prior to the building of the New Market Hall a major archaeological excavation was carried out. This revealed a Roman street with houses on either side that had mosaic floors and a piped water supply.

Blackfriars

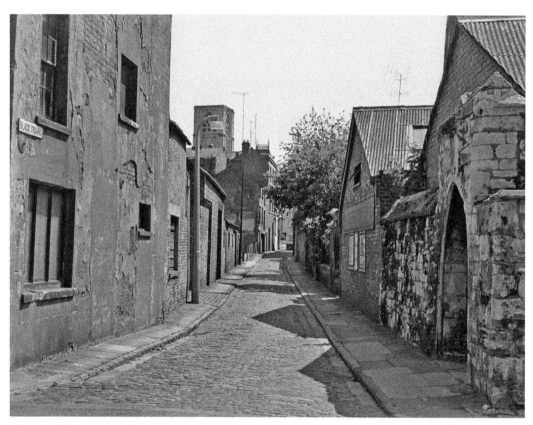

The lane derived from the entranceway into the precinct of the thirteenth-century Dominican priory from Southgate Street. It later ran through to Ladybellegate Street and also gave access to Blackfriars Square within the cloisters of the priory. The single-storey buildings on the right were occupied by Gloucester Printers Ltd. The cobbled surface of the lane was destroyed during the creation of the Via Sacra walkway around the city centre.

Bristol Road

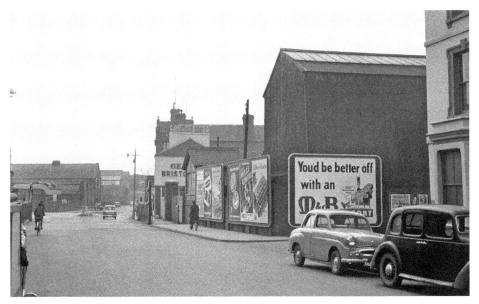

The Sudbrook railway crossing marked the start of the main road to Bristol. This is now the junction with Trier Way and St Anne's Way.

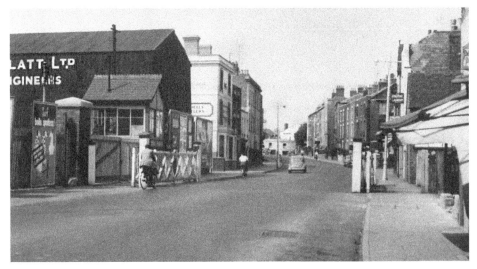

The Sudbrook crossing was created in 1848 when the Midland Railway built a branch line alongside the brook to High Orchard and the docks. This railway line also served the factories of Fielding and Platt and the Gloucester Railway Carriage and Wagon Works.

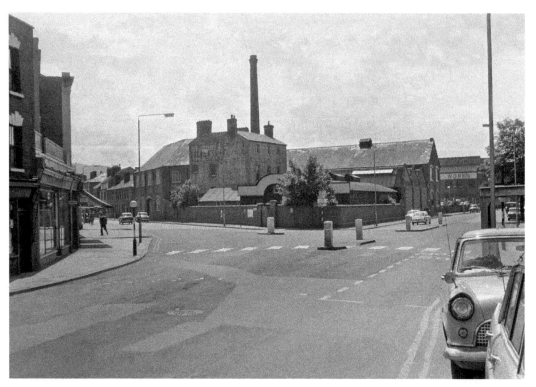

At the junction of Bristol Road and Stroud Road can be seen the tall chimney belonging to the Southgate Mills of the Gloucester Carpet Co. Ltd. In the distance is part of the works of Morelands match factory.

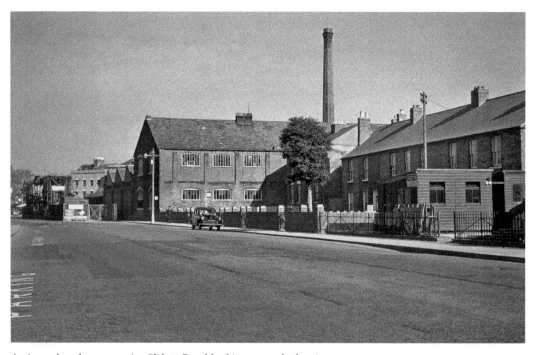

A view taken from opposite Clifton Road looking towards the city centre.

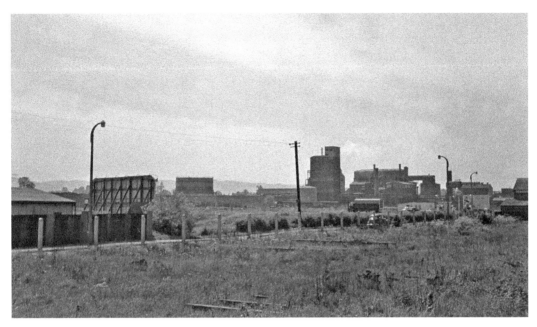

The Gloucester Gas Works were built between 1874 and 1877 to replace those set up by the Gloucester Gaslight Company in Quay Street in 1819. The production of gas at the Bristol Road plant was replaced by natural gas from the North Sea in the 1970s. The photograph was taken from a point adjacent to Hempsted Bridge.

The junction at Bristol Road and Cole Avenue opened in 1959 on the completion of the ring road around the city. The simple roundabout has now been replaced by an intricate complex of multi-lane roads and traffic lights. This view is looking towards the east with Robinswood Hill in the background.

Brunswick Road

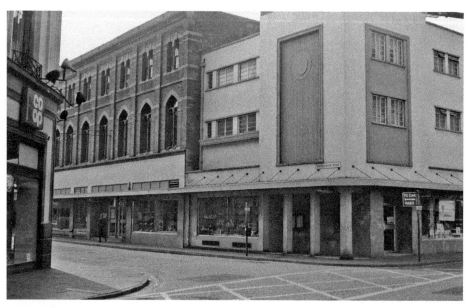

The Gloucester Co-operative and Industrial Society was formed in 1860 and by 1910 had eighteen branches in the city. These premises on the west corner of Brunswick Road were first built in 1867 and extended in 1883 and 1904. The site is now occupied by Boots UK who redeveloped the site and opened their new store in 1980.

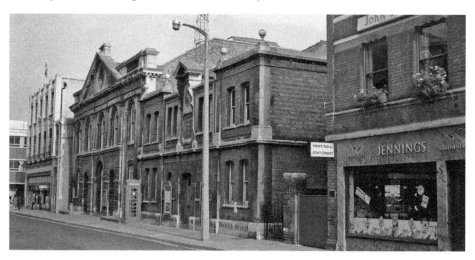

The Baptist Church and Raikes Memorial Hall. The church and schoolrooms were opened in 1821 and rebuilt and enlarged in 1847.

Brunswick Road was known as Parkers Row in the early nineteenth century and originated as a track alongside the ditch of the eastern defences to the medieval town.

The Christ Church National School for Girls opened on the corner of Brunswick Road and Park Road in the early 1840s. An infants' room was added in 1894 and the school became infants only in 1938. It closed in 1958. The unusually large post box had two separate compartments; one each for first- and second-class mail.

The Cattle Market and Its Surroundings

The cattle market first opened on this site in 1823 and was further improved and extended in the 1860s. Prior to this time livestock sales took place at different sites and streets within the city. The cattle market moved to a new site at St Oswald's Road between 1955 and 1958 and the area was used for the building of Grosvenor House and the bus station.

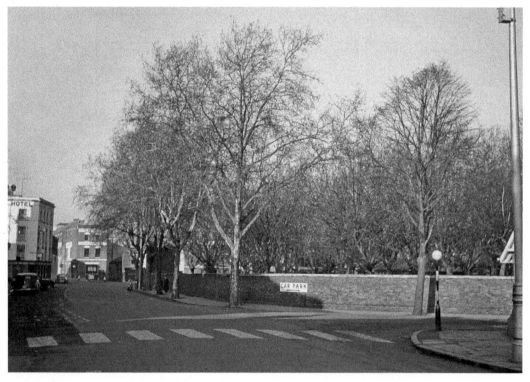

The cattle market, with the forest of trees that provided shelter for the livestock, as seen from Station Road.

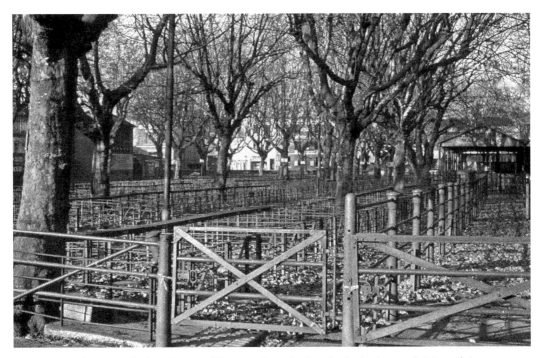

Livestock pens with the sale ring of J. Pearce Pope & Sons in the background. Most of the trees were removed for the construction of the bus station.

The cattle market entrance from Station Approach looking towards Station Road.

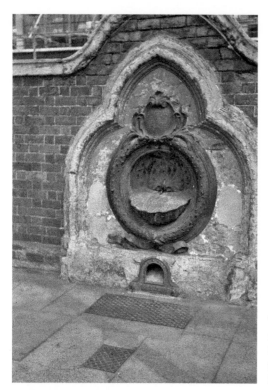

The Victorian drinking fountain was set into the perimeter wall of the cattle market facing Clarence Street. Around the small aperture at the base of the fountain are the words 'LOVE ME LOVE MY DOG'.

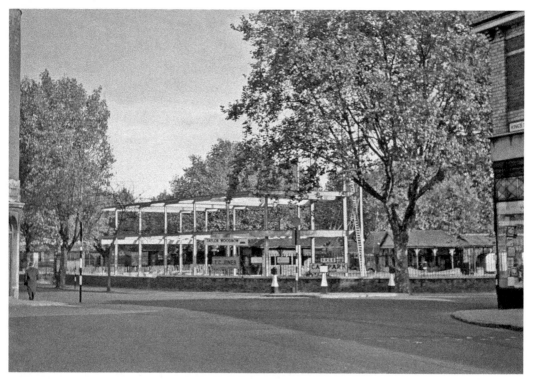

Work beginning on the first phase of Grosvenor House and the bus station.

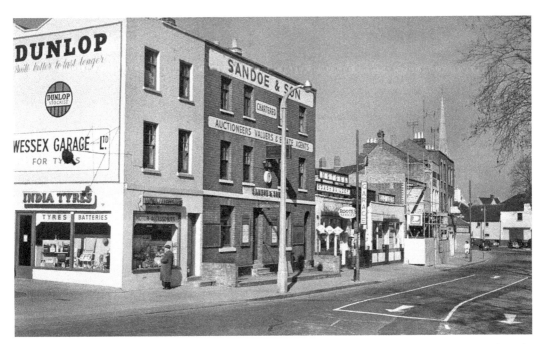

Market Parade on the western side of the cattle market. On the extreme left of the photograph is the small forecourt of the Wessex garage. Due to limited access to the petrol pumps customers would drive onto a turntable and after filling up with fuel the car would be rotated through 180 degrees to exit.

Like other hotels and pubs in this area the Spread Eagle Hotel derived a good deal of trade from the cattle market. The hotel was said to have superior facilities for dining and entertainment and hosted meetings of several local organisations. It closed its doors in 1972.

The corner of Market Parade, now Bruton Way, and London Road junction.

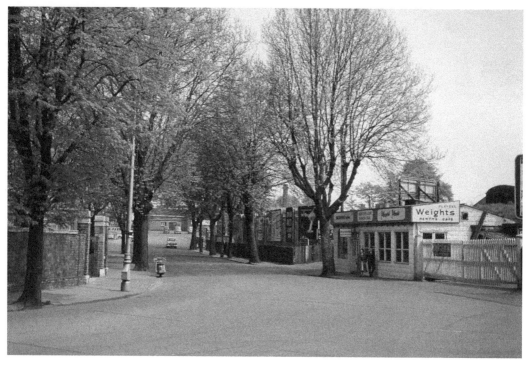

Station Approach looking towards the Central station. The area to the right is now occupied by the offices of the Land Registry.

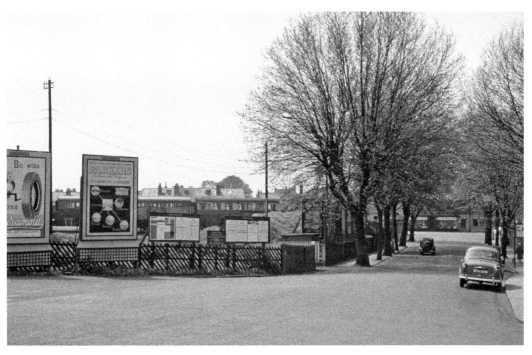

Station Approach looking towards Station Road with the railway sidings and the Western region coal wharves on the left-hand side.

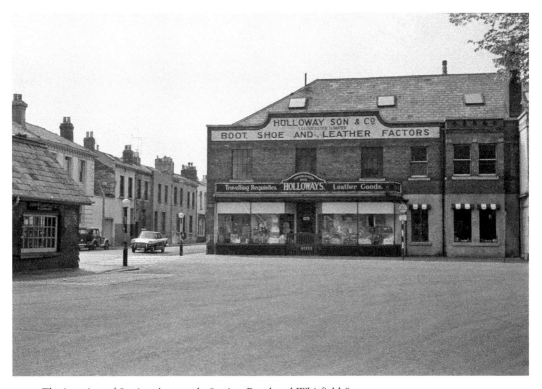

The junction of Station Approach, Station Road and Whitfield Street.

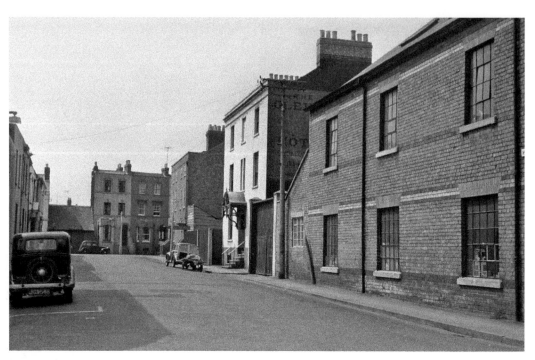

A view of Whitfield Street looking towards Russell Street. The Glevum Family Hotel with a fancy canopy to the entrance doorway stands out from the more prosaic buildings on either side.

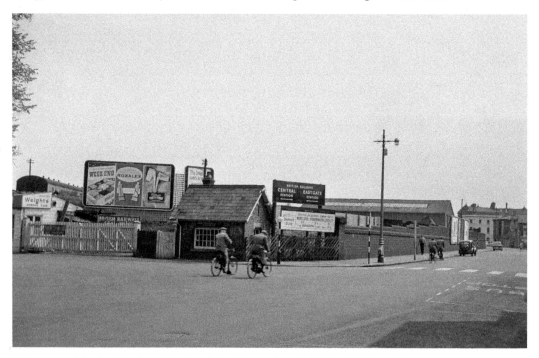

The corner of Station Road was the site of the office and weighbridge of John Williams & Co. Ltd coal merchants. The wall alongside Station Road still exists although it's now reduced to a few courses in height along much of its length.

Station Approach became part of Bruton Way that was the first section of the inner ring road built between London Road and Station Road in 1962.

Clarence Street

The development of Clarence Street began in the 1830s with construction of houses for professional men and their families. The street provided a link from Eastgate Street and Barton Street through to the cattle market and the Central station.

Most of the west side of the street was removed to make way for the new development on the east side of King's Square but fortunately the fine terraced houses on the east side still remain today.

Commercial Road

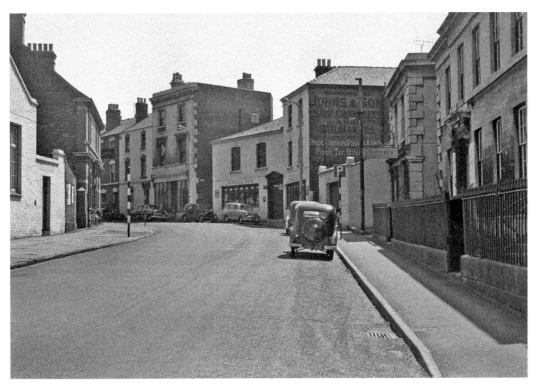

The premises belonging to Johns & Son, ships chandlers and sailmakers, were demolished in 1962 to make way for a section of inner ring road through the Kimbrose area.

Dog Lane

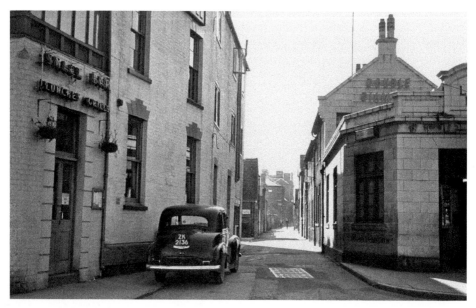

The lane has its origins as a way alongside the defensive ditch of the medieval town from the east gate through to Brook Street, the later Market Parade. On the right is the Lamb, a pub that was very popular on market days. The site is now covered by the ramp to the multi-storey car park above Eastgate Street.

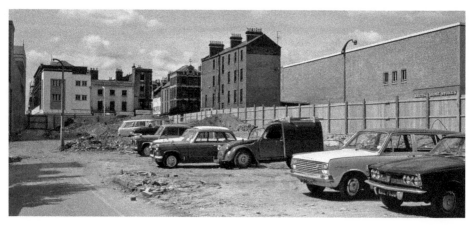

All the properties between Dog Lane and King Street were removed including the works of John Bellows, the printers that occupied most of the site in the photograph. During archaeological excavations in 1969 a medieval defensive bastion was discovered here, attached to the Roman Wall, and was subsequently preserved below the new development.

Eastgate Street

This was probably the least important of the main streets in the city until the nineteenth century. With the arrival of the railways to the east of the city centre a number of exuberant buildings were erected including banks and the Guildhall.

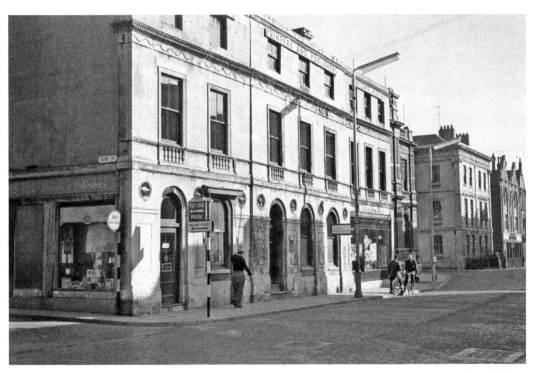

Eastgate House between King Street and Dog Lane (the entrance can just be seen behind the two cyclists) was occupied by John Bellows printers and publishers and Thomas Cook & Son travel agents.

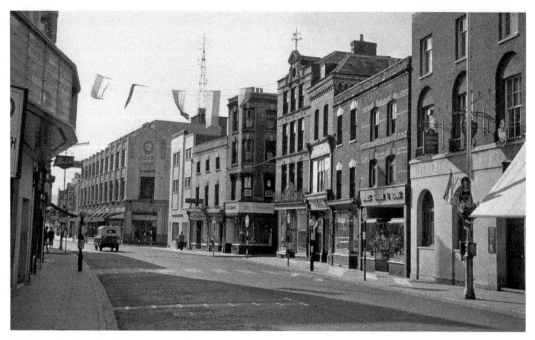

The row of properties from Brunswick Road to Queen Street included the Co-operative Society Building, Fry & Son confectionary shop, and Eastman's the butcher. From the west side of Queen Street are Parsons Brothers, ironmongers, David Greig's grocery shop, Baker's shoe shop, and the District Bank.

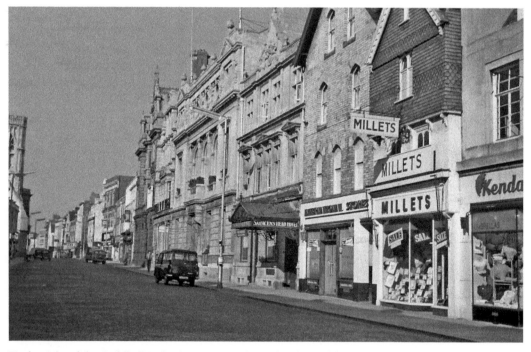

To the right of the Guildhall is the Saracen's Head Hotel. It began life in the seventeenth century as a simple beer house but was rebuilt in 1890 as a well-appointed hotel. Next door is the International Stores, followed by Millets the outfitters, and Kendall umbrella makers.

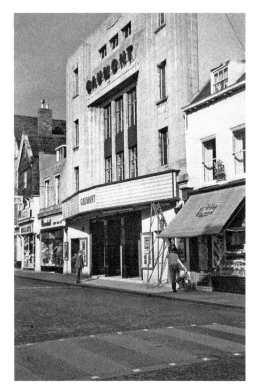

Immediately to the east of Kendall's was the Gaumont Cinema. The first cinema built on this site opened in 1911 under the name The City Cinema. Following a major refurbishment in 1915 it was renamed the Hippodrome. The cinema was badly damaged by fire on the 23 October 1955 but reopened on the 18 June 1956 as the Gaumont. It closed in April 1961 and was demolished in 1964.

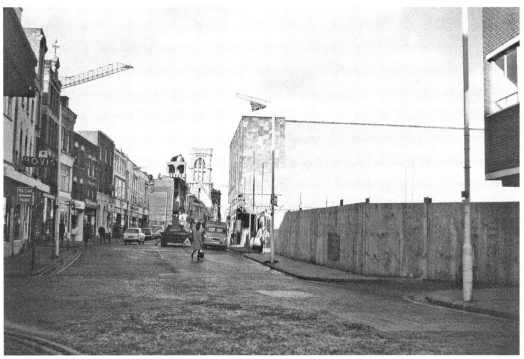

Construction work between the Guildhall and King Street began with the building of a new outlet for the now defunct British Home Stores.

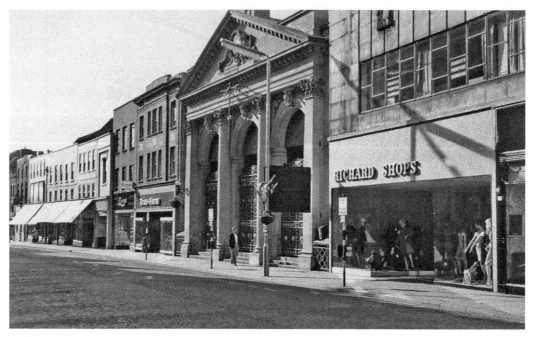

The Eastgate Market was created in 1786 in order to remove the many traders from the congested streets in the city centre. The impressive portico was added during a major rebuilding in the 1850s. The portico was dismantled and rebuilt further to the east during the redevelopment of the 1960s.

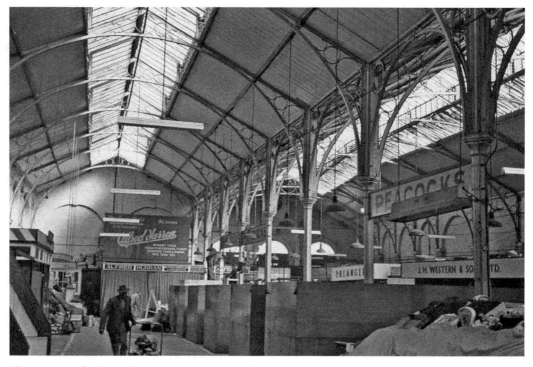

The interior of the market was occupied by thirty-eight traders that included six butchers and seven fishmongers.

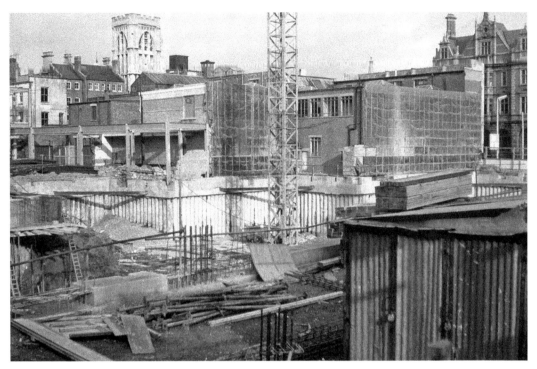

Construction work is in progress on the site of the old Eastgate Market in the late 1960s.

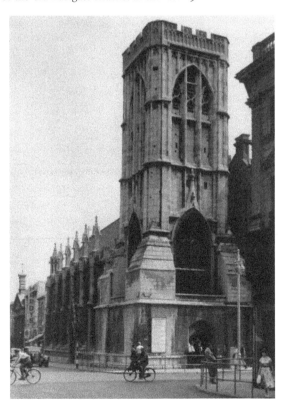

The church of St Michael as it was prior to the demolition of the Victorian nave.

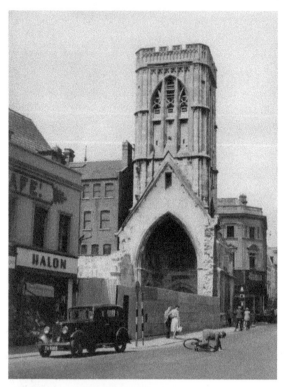

The demolition of the nave took place in 1956 leaving just the fifteenth-century tower standing. The sight obviously had a profound effect on an elderly cyclist.

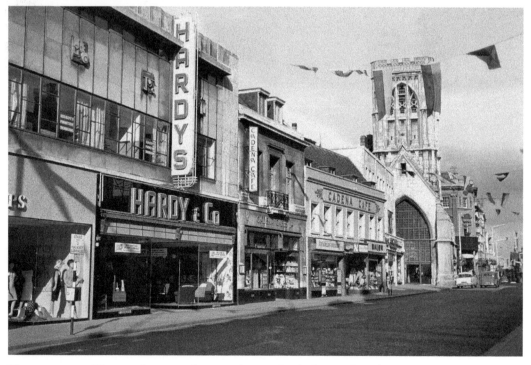

The upper part of Eastgate Street was home to the popular Cadena Café with its ever present aroma of roasting coffee. Just beyond the café are the shops in the newly constructed St Michael's Buildings.

George Street

The street was created following the arrival of the railways in Gloucester. It ran from the approach to the Great Western station through to London Road at a point almost opposite St Peter's church. It was originally named Church Street.

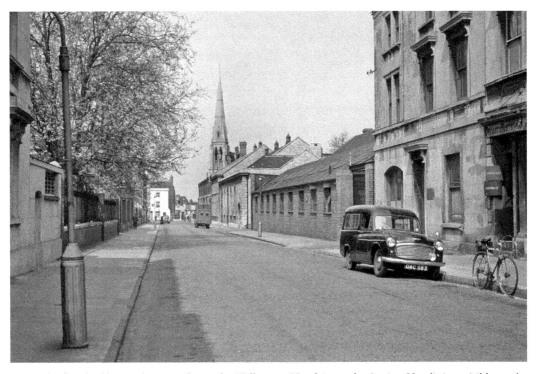

The first building to be erected was the Wellington Hotel (now the Station Hotel), just visible on the left, followed by the Gloucester Hotel, opposite, in 1854. Due to its proximity to the railway most of the street on the northwest side became occupied by the postal sorting offices.

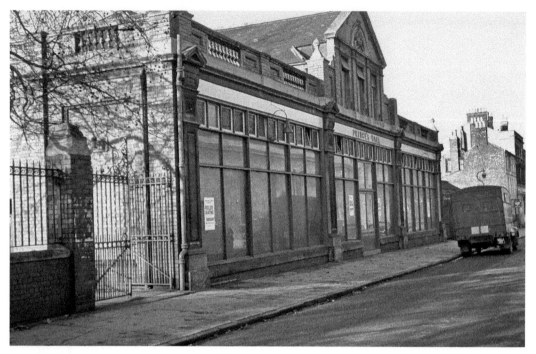

The Prince's Hall became a popular dance hall during the 1930s. In later years it became noted as venue for roller skating and popular entertainment. It was built in 1898 as a showroom for road vehicles made by the Gloucester Railway Carriage and Wagon Company.

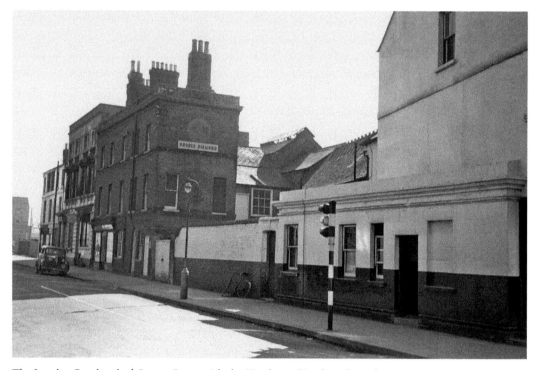

The London Road end of George Street with the Northgate Hotel on the right.

Greyfriars

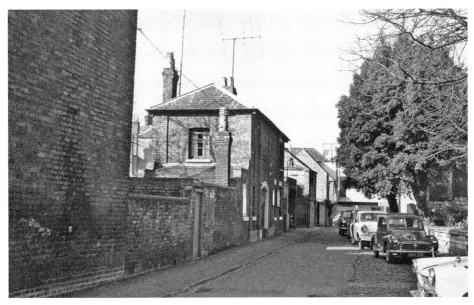

The Friends Meeting House was opened in 1834 when the Quakers moved from their long established home in Park Street. The lobby and schoolroom fronting onto Greyfriars was built in 1879. Set into the floor of the entrance porch is a panel of Roman mosaic said to have been discovered during building work.

The footway from Brunswick Road narrowed considerably as it approached the site of the priory remains. The end building on the right housed the salon of Madame Florence, ladies and children's hairdresser.

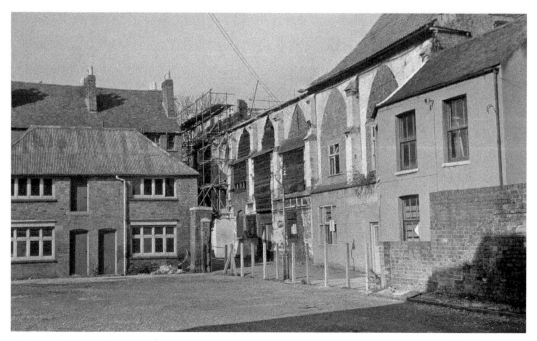

The later additions at the western end of the priory's sixteenth-century nave arcade under removal. The rest of the modern alterations to the priory were subsequently taken away leaving the church nave and north aisle as a free-standing monument.

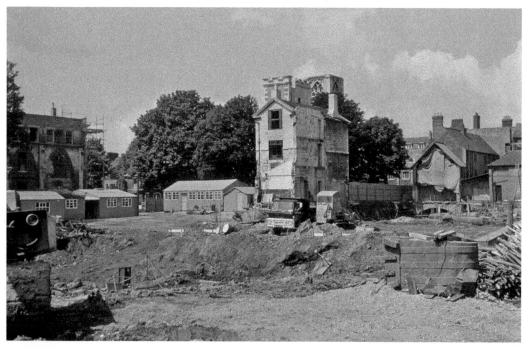

Addison's Folly was built by Thomas Fenn Addison in 1864 as a memorial to Robert Raikes a pioneer of schools on Sundays. It is said that the tower was built just high enough to give Addison a view of Hempsted church where his wife was buried.

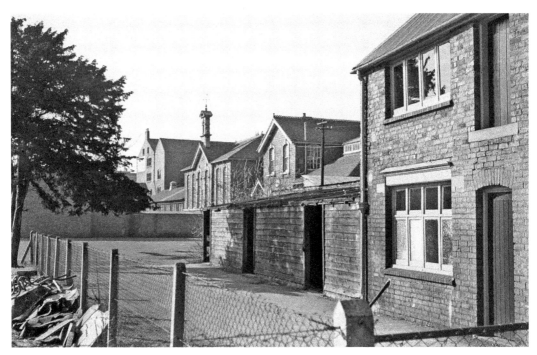

The buildings at Friar's Orchard were occupied by the Crypt School following the move from Barton Street 1889. In 1943 the school moved to its present site at Podsmead.

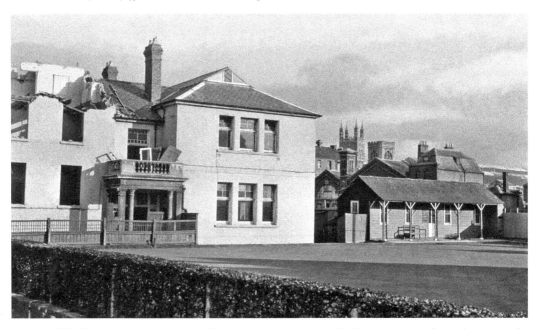

Suffolk House was built in the early nineteenth century and in later years was better known as the children's library, established in 1938, and the music and gramophone record library that started in 1963. The bowling green was laid out in 1921 for the Gloucester Liberal Club who occupied the building from 1890 to 1927. Following demolition of the house the site was used for part of the New Market Hall building.

Hare Lane

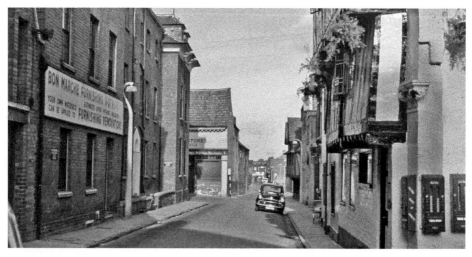

Hare Lane was the main way into the city centre from the Tewkesbury Road until the construction of Worcester Street in 1822. The Bon Marche Furnishing Workshops building on the left were originally part of the premises used by the St Lucy's Home of Charity from 1876. These buildings were cleared away in the 1970s and the resultant public open space became St Lucy's Garden.

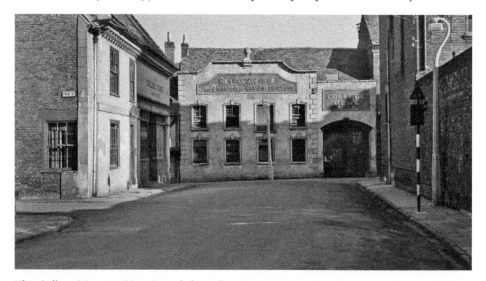

The College Mews in Hare Lane belonged to George Symonds who operated a carriage hire business. He also had a fleet of horse-drawn buses that operated on the Tuffley to Hucclecote route in the 1890s. The mews site is now occupied by a Sainsbury's store. On the left the entrance to Park Street can be seen, which ran parallel to Hare Lane down to St Catherine Street.

Hempsted Lane

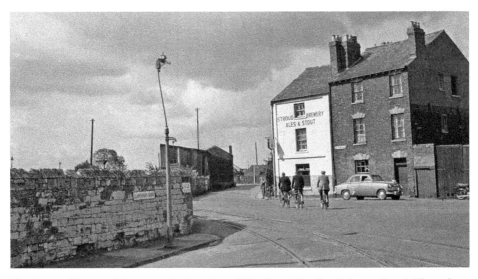

The lane to Hempsted began at the junction of Llanthony Road and Severn Road. The pub on the corner was the original Sir Colin Campbell beer house that opened in the 1860s. The building was demolished in 1968 and rebuilt further to the west towards the river. The pub was renamed later as The Inn on the Docks, which closed in 2010.

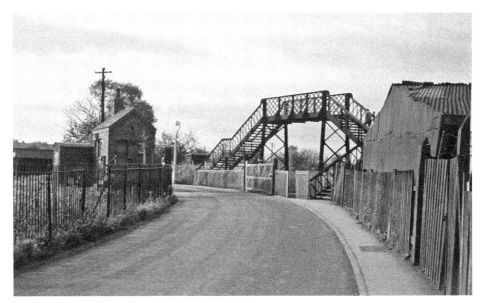

The footbridge over the railway branch line leading into the docks.

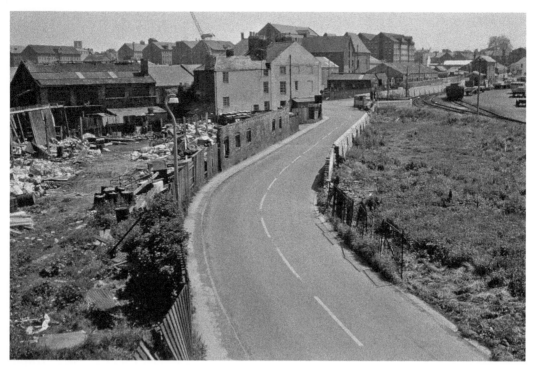

The photograph shows the northern end of Hempsted Lane as seen from the footbridge.

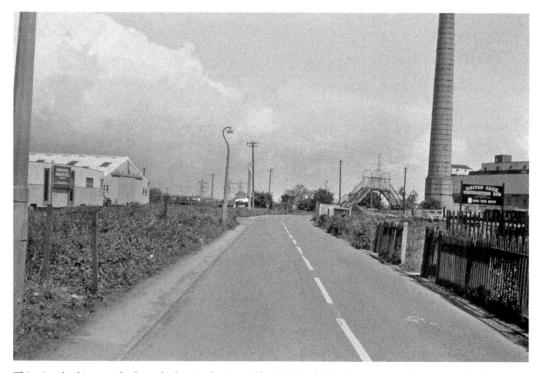

This view looking north along the lane is dominated by the Castle Meads power station across the river on Alney Island.

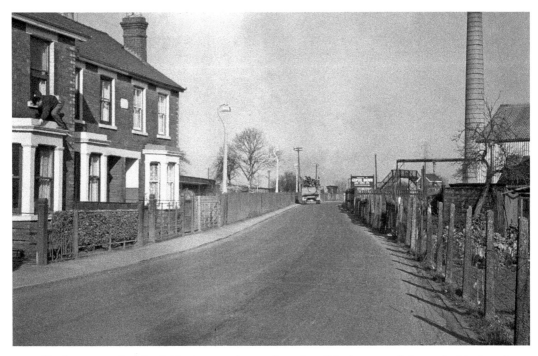

The houses on the left of this photograph were later demolished as part of the road widening scheme for South West Bypass in spite of the maintenance carried out by one intrepid occupant.

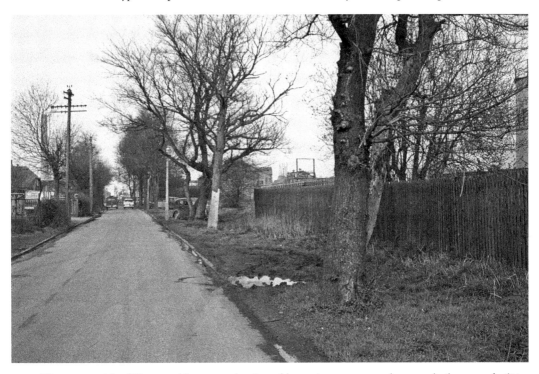

The eastern side of Hempsted Lane was dominated by various scrap merchants and oil storage facilities associated with Monk Meadow Dock.

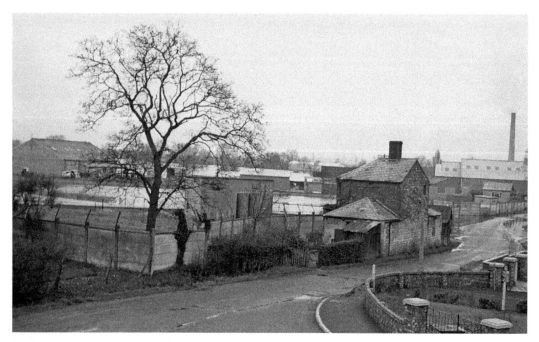

The far side of the flooded area beyond the large tree is now the site of the entrance road into the Hempsted Recycling facility. The small buildings by the roadside were later removed for widening the lane.

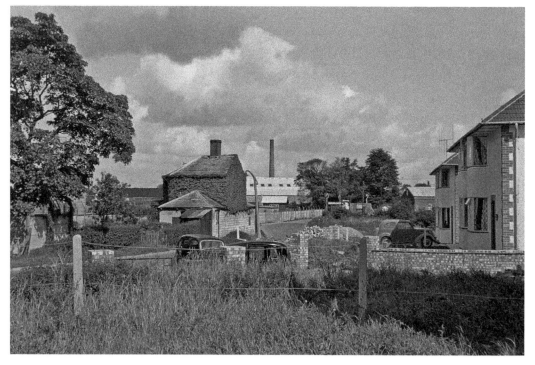

The ivy clad building in the centre of the photograph was originally the lodge at the entrance to the driveway of Newark Park.

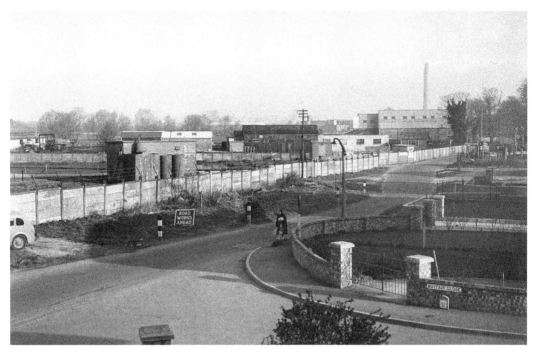

Following the removal of the small buildings near Mayfair Close a new fence was erected on the west side of the lane in preparation for road improvements.

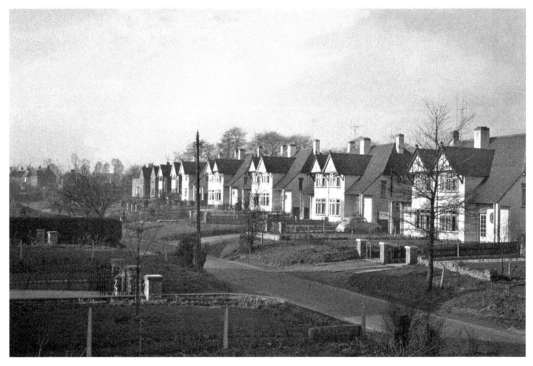

This row of semi-detached houses stands on the west side of the lane and shows the view prior to the removal of the grass verges.

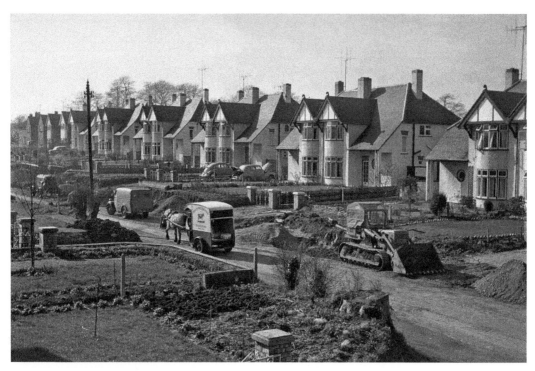

The horse-drawn milk float belonging to Hempsted Dairies passes the road construction vehicles.

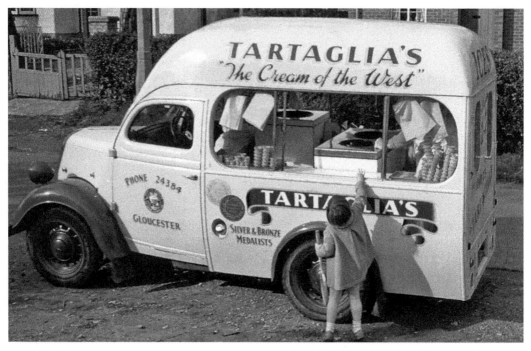

Several of the previous photographs were taken by John Rowden from the bedroom of his house in Hempsted Lane. This one, taken in 1953, features his three-year-old daughter Lesley at one of Tartaglia's ice cream vans.

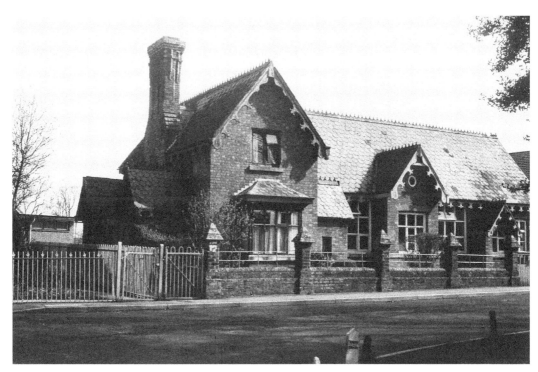

The village school in St Swithin's Lane opened in 1851.

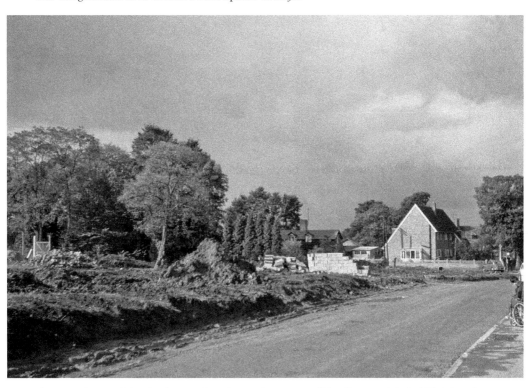

Construction work begins for new housing at the corner of Rea Lane and St Swithin's Road.

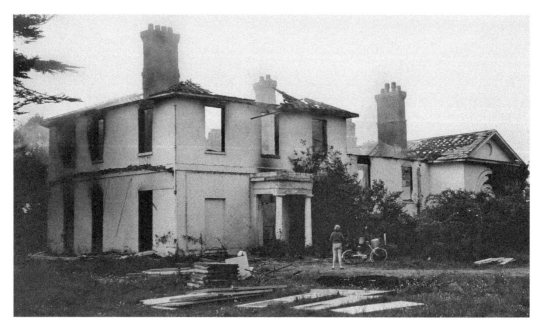

Elm Lodge once formed part of the Hempsted Court Estate owned by Daniel Lysons, a Gloucester linen draper, in the late seventeenth century. The house stood opposite Hempsted Lane at its junction with St Swithin's Road. The handiwork of the demolition contractor is inspected by John Rowden's daughter Louise.

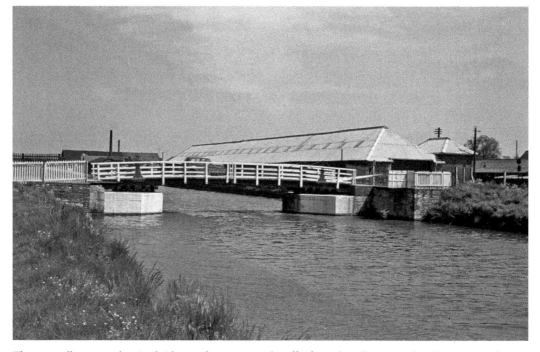

The manually operated swing bridge used to carry road traffic from the village over the Gloucester and Sharpness Canal. The long white-roofed building on the opposite bank was once used as a store by the Droitwich Salt Company.

King's Square

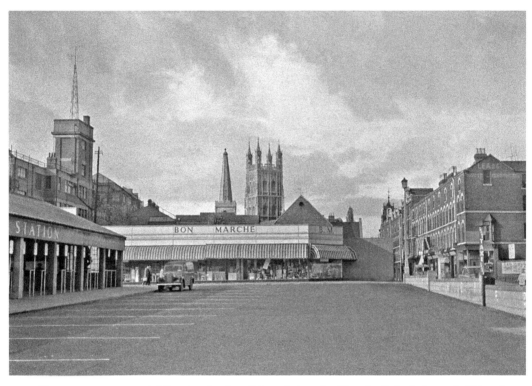

The square was created following the demolition of slum dwellings in Oxbody Lane, St Aldate Street and King Street between 1927 and 1929. The northern part of the square was used as the terminus for buses on the country routes.

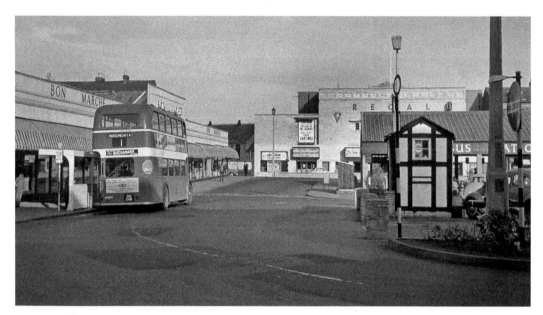

The southern part of the square held the city bus services with the stops arranged around a central car park. An echo of the area's medieval past was provided by the timber-framed hut for the car park attendants. Construction work on the Regal Cinema began in 1939 but came to a halt following the outbreak of the Second World War. Building restarted in 1955 with the original plans altered to include theatre staging and lighting equipment. The Regal finally opened in March 1956.

Demolition of parts of King Street on the east side of the square continued in a piecemeal fashion through the 1960s. The brick building on the extreme right was the Ebenezer Gospel Hall built in 1872 by a group of Christian Brethren. This hall eventually disappeared in 1970 when the Brethren moved to a new site in Russell Street.

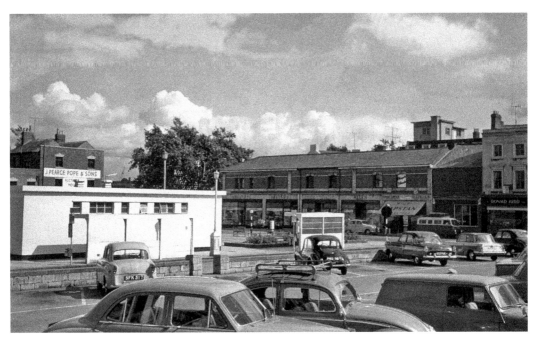

Illuminated Christmas decorations were provided in the main thoroughfares by the city council from the early 1960s. The flat roof of the white toilet block in the square provided an ideal platform for some interesting and imaginative displays.

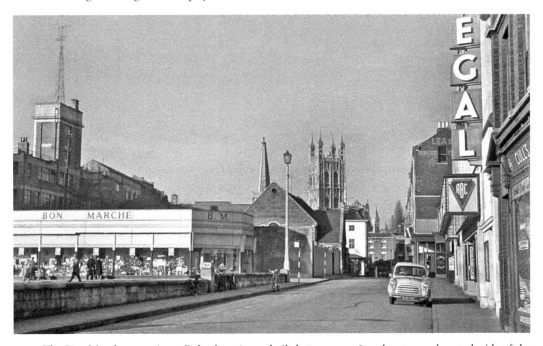

The Bon Marche store (now Debenhams) was built between 1928 and 1931 on the north side of the Oxbode. A single-storey extension was added later along the western side of the square following the demolition of properties in St Aldate Street. In front of St John's Church and the tower of the cathedral is the Church of St Aldate.

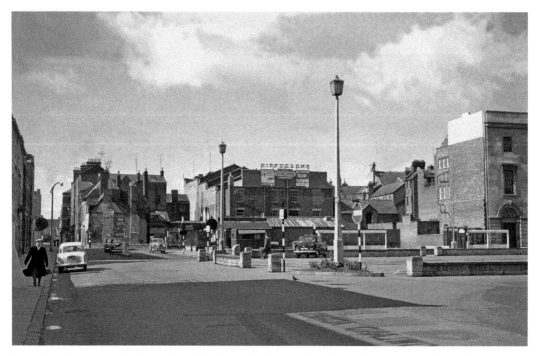

This view of the square, looking along King Street, is dominated by the bulk of the Hippodrome cinema in the centre with the main Post Office on the extreme right.

This view of the southern end King Street was taken from the eastern end of New Inn Lane. The long building on the left housed the printing works of John Bellows. The buildings on the right have some interesting details on their façades and the gable end and roof lines suggest a medieval origin.

The rear part of the Hippodrome cinema dominates the scene along New Inn Lane. The large building beyond is the Guildhall.

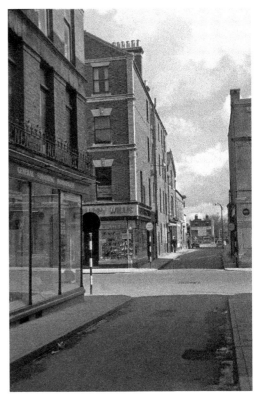

This photograph of King Street was taken from the south side of Eastgate Street in Queen Street.

Ladybellegate Street

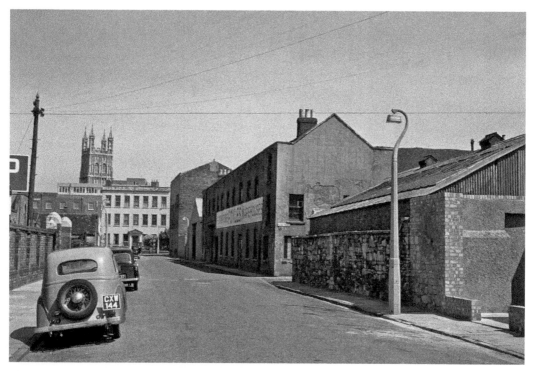

The street is named after Lady Joan Bell the wife of Sir Thomas who purchased Blackfriars Priory in 1539. The main gate to the property was at the northern end of the street at the junction with Longsmith Street. The large building on the corner of Blackfriars lane was a storage warehouse used by Foyles furniture store in Southgate Street.

Llanthony

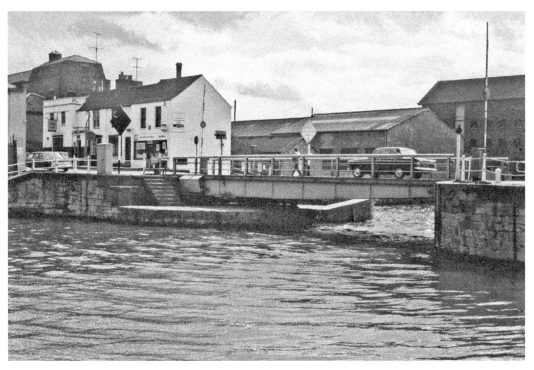

This swing bridge was opened in 1862 to carry Midland Railway traffic to the west side of the canal. It replaced the original wooden structure that was built for the opening of the canal in 1827.

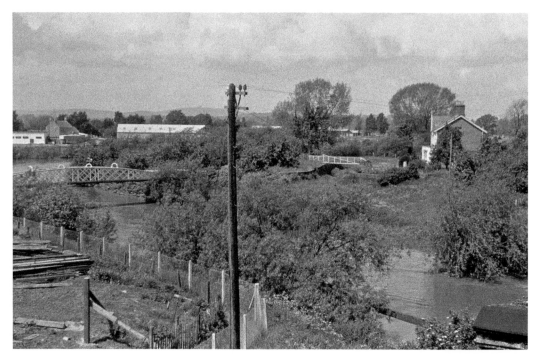

The lattice-work bridge across the Severn was built in 1908 to give pedestrian access to the keeper's house at Llanthony Lock. Prior to that time only the lock-keeper was allowed to cross the river via the nearby railway bridge. Other members of the family had to use a small rowing boat and cross just upstream of the weir.

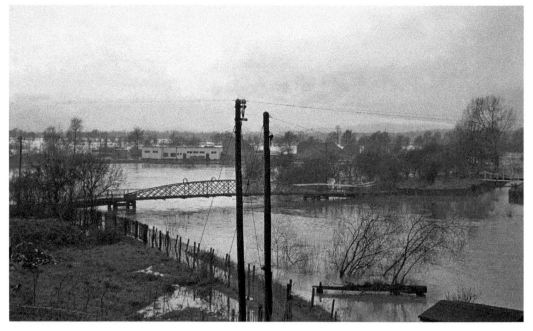

The advantage of a footbridge instead of a rowing boat from the lock across the Severn is clearly demonstrated in this photograph taken during one of the regular winter floods.

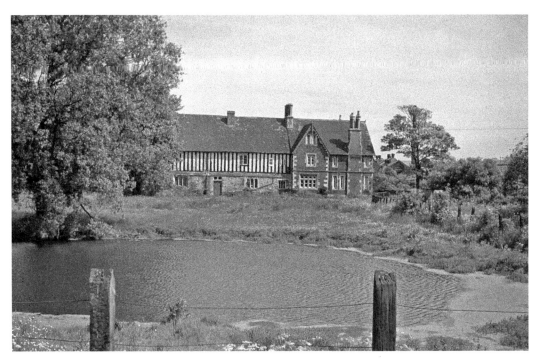

Llanthony Priory, originally known as Llanthony-by-Gloucester, was founded in 1137 by Augustinian canons from Llanthony in Wales. Following the Dissolution in 1538 it became the principle house of Arthur Porter MP. In later centuries it was used as a farmstead and the pond in the foreground dates from the 1850s.

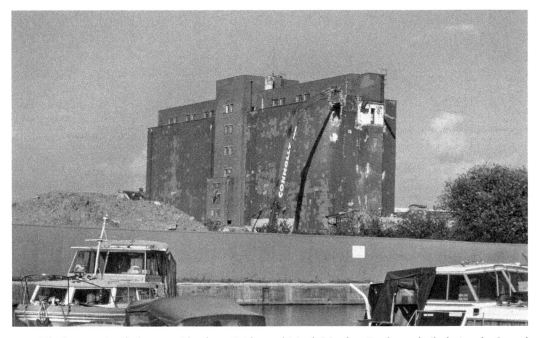

The large grain silo between Llanthony Bridge and Monk Meadow Dock was built during the Second World War for the drying and storing of large amounts of locally produced wheat.

London Road

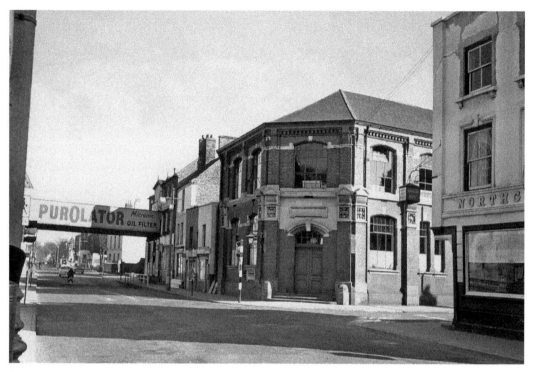

The building on the corner of George Street was originally opened in 1894 as a showroom for products of the Gloucester Railway Carriage and Wagon Company. From 1904 it was occupied by the Post Office as an extension to its mail sorting facilities adjacent to the GWR station. It has recently been sympathetically restored as architects' offices.

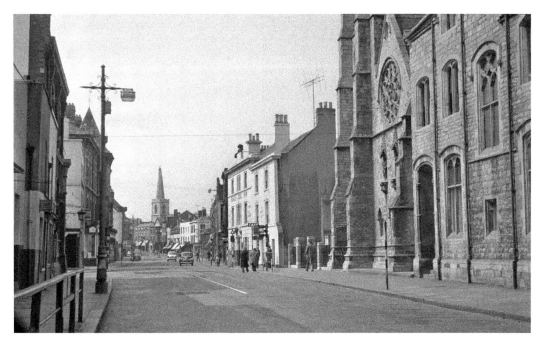

Beyond St Peter's Church is the Black Dog Inn with its distinctive canine draped over the parapet. When the pub was demolished to make way for the construction of Black Dog Way the large creature was rescued and can be seen today in the Gloucester Life Museum in Westgate Street.

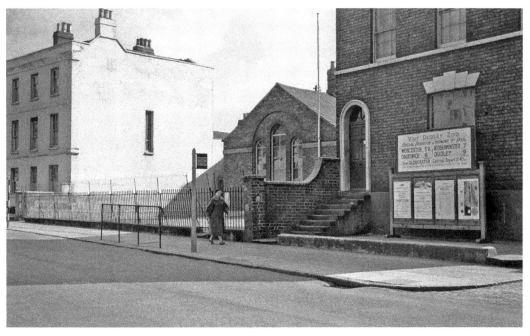

Set back from the road between the railway bridge and Great Western Road is the National School that closed in 1962. The foundation stone was laid by the Duke of Wellington during his visit to Gloucester in 1816 and the nearby Wellington Parade was named in his honour. The board advertising rail excursions from the Central station makes interesting reading with a trip to Dudley Zoo for just 45p.

Longsmith Street

In the medieval period this street was the main metalworking area in the town. The area at the lower part of the street is the Bearland, not a home for bears, just the area of bare land that once surrounded the medieval castle.

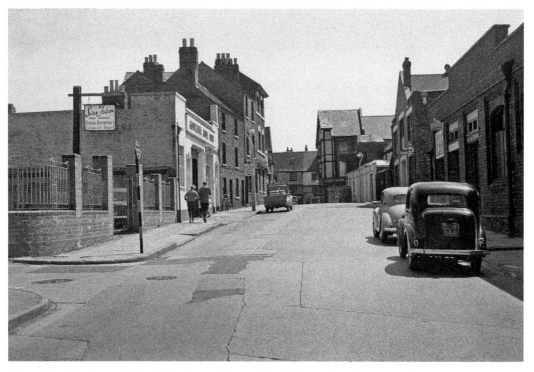

The road leading off to the left is Bull Lane and most of the buildings from there towards Southgate Street were later removed to make way for the multistorey car park. The Swan & Falcon pub first opened for business in the early eighteenth century and closed in 1965. The Gloucester Model Dairy had premises on both sides of the street and the pick-up truck parked outside is loaded with milk churns.

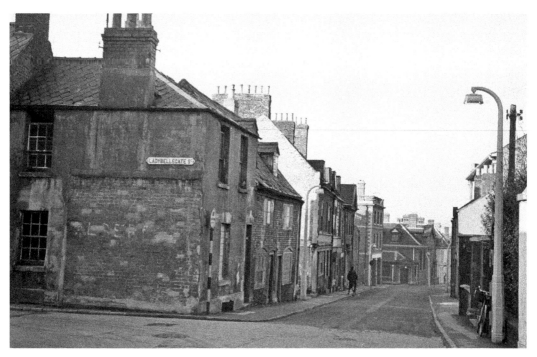

The house and cottages at the junction of Ladybellegate Street are boarded up ready for imminent demolition. Although there is a lack of graffiti in the city at this time it seems that Albert decided to leave his mark.

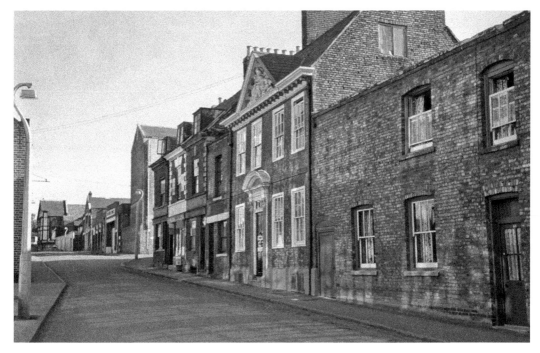

In this view looking towards Ladybellegate Street the house and cottages on the corner have been demolished. The remaining houses down to Bearland Lodge survived until the 1970s.

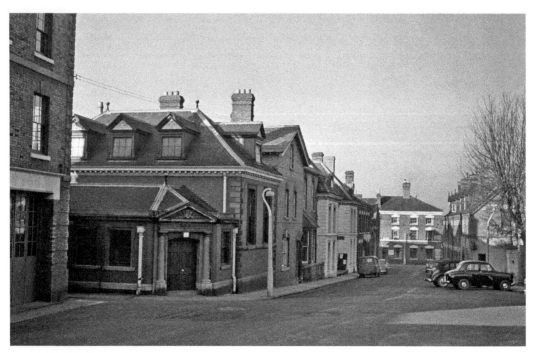

On the corner of Barbican Road and Longsmith Street are the county magistrates' courts built in 1908.

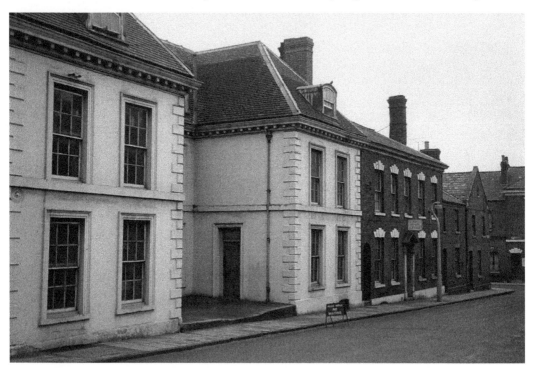

One of the finest ornamental gardens in Gloucester was created by the Hyett family at the rear of Marybone House in the 1740s. Much of the garden was taken for the building of the new county gaol that opened in 1791, and the house was used as the city's main police station from 1858 until the 1960s.

Northgate Street

The North Gate was the main entrance to the city where, since Roman times, the roads from the north and the east converged. By the Middle Ages the street had become one of the principle trading and market areas of the city.

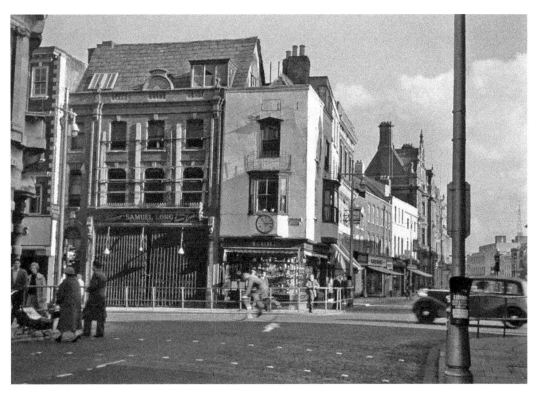

The upper part of Northgate Street at the Cross was dominated by the businesses of Mann's the jewellers and Samuel Long a fishmonger and game seller. Both these buildings were medieval in origin that had been refronted in the eighteenth century. Early photographs show the front of Long's shop festooned with up to 200 items of game birds and poultry at Christmas time, all exposed to the air and traffic fumes.

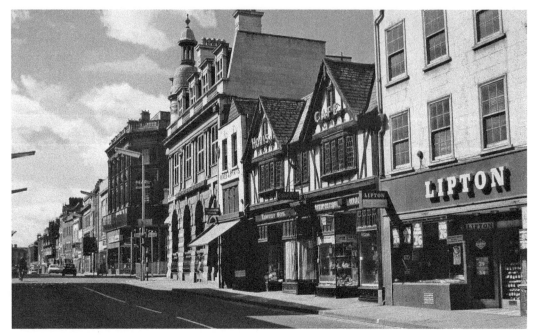

Despite its name and looks the Tudor Café was not built until the 1930s. The café operated on the upper floor with Lawrence Brothers bakery shop, Frederick Wright, tobacconist, and Woolies wool shop below.

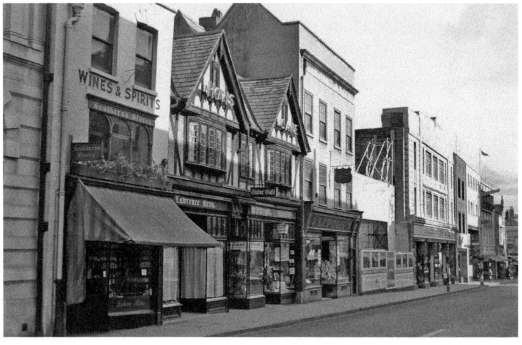

The demolition of Southern's Stores provoked a wave of public interest when it was discovered that a fifteenth-century house lay behind its Victorian façade. The loss of this and other ancient buildings around that time was a catalyst in the formation of Gloucester Civic Trust in 1972.

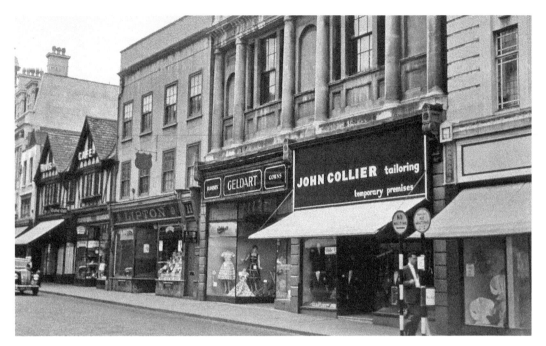

The well-known clothing retailers Geldarts and John Collier occupied the premises that were built in 1801 for the banking firm of Fendall, Evans & Jelf. Due to the failure of this and other banks in the city, the Bank of England opened a branch here in 1826 in an effort to stabilise the local economy. The building was taken down for an extension to the adjacent Marks and Spencer store.

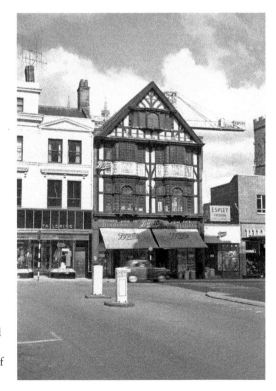

Boots the Chemist established a store behind this mock-Tudor façade before the First World War. The store was rebuilt and enlarged in the late 1950s and closed following the opening of a new store in Eastgate Street in 1980.

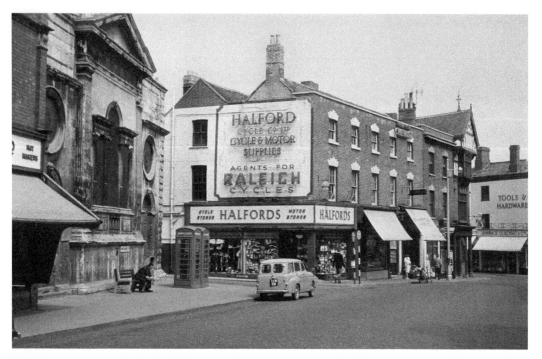

Following the removal of the Halfords cycle and motor store building a major archaeological excavation took place. The dig revealed the extensive remains of the Roman north gate and other buildings associated with it.

The development on the north side of St Aldate Street began in 1866 with establishment of workshops for Edwin Lea, a furniture-maker and upholsterer, who began trading from a shop on the corner of Northgate Street.

The street is named after the Church of St Aldate that stood on the north side of a square of that name that is now occupied by the service yard of Debenhams. The church is recorded from the year 1205 and was later rebuilt and reopened in 1756. The church closed in 1931 when the parish was united with St John and the building was converted into a parish hall. The building was demolished in 1963.

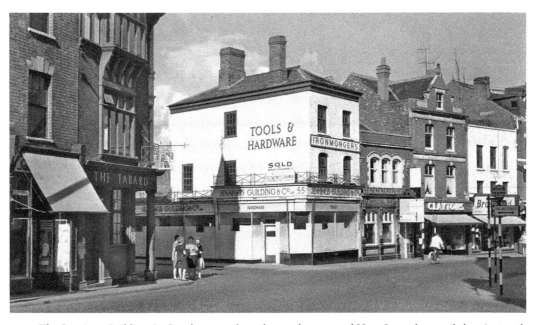

The Jennings Guilding & Co. shop stood on the north corner of Hare Lane that until the nineteenth century was the main road into Gloucester from the north.

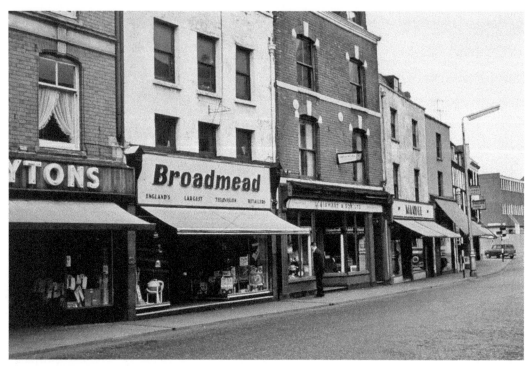

Nos 61–71 Northgate Street premises shortly before demolition.

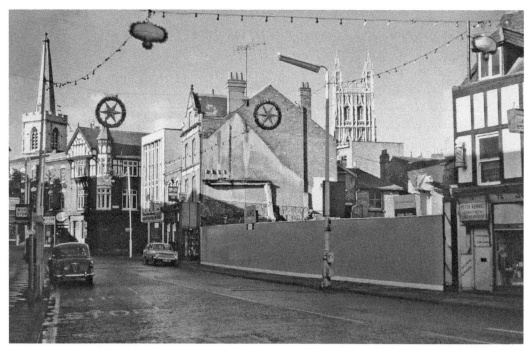

In this photograph the Jennings Guilding & Co. building on the corner of Hare Lane has been replaced by a prosaic structure housing the Bristol and West Building Society. This interesting view of the cathedral tower disappeared on completion of the new Sainsbury's store.

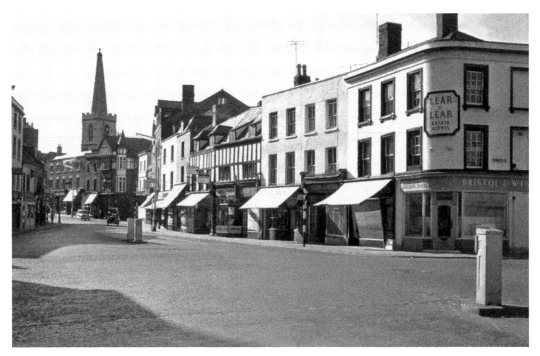

Some of shops between Hare Lane and Worcester Street have retained their original decorated shop fronts and also deploy awnings to protect their window displays from sunlight.

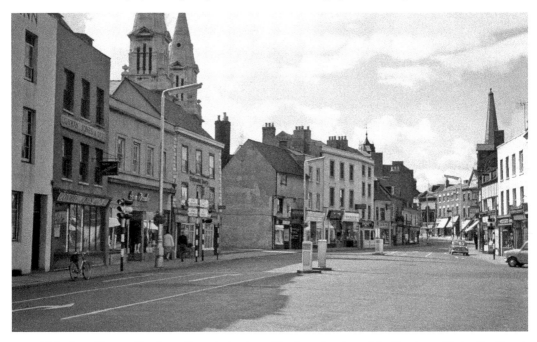

This view of Lower Northgate Street is dominated by the twin spires of the Northgate Methodist Chapel. To the right of the chapel is the timber-framed Red Lion Inn that traded from the early eighteenth century until 1920. This building together with the chapel and most of the premises to the south were all taken down for the building of a Tesco supermarket that traded there for a mere eleven years.

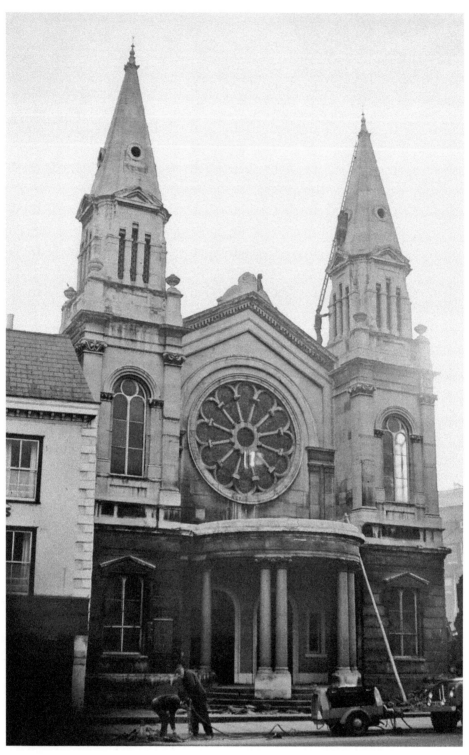

The demolition work on the Northgate Methodist Chapel, directly opposite Worcester Street, began with the removal of the spires at its western end by two intrepid workmen.

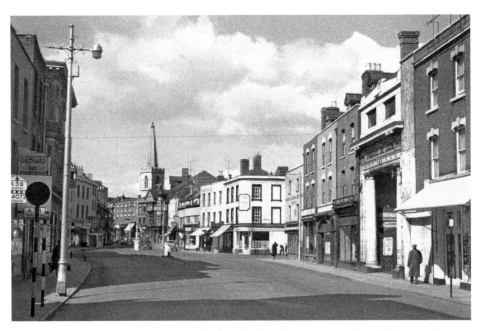

The grand pillared building on the right hand side of the street is the old Theatre de Luxe Cinema. In 1929 it became the fourth cinema in Britain to install sound. As a result of this the rail companies ran special excursions to Gloucester from Birmingham and Bristol. The cinema closed following a disastrous fire in 1939 and due to the outbreak of the Second World War it was never rebuilt.

At the time this photograph was taken the upper floors of Northgate Mansions, on the corner of Market Parade, were occupied by the offices of the District Superintendent of the Western Region of British Railways. On the ground floor were WHSmith, booksellers, Pickford's furniture removers, and Quality Cleaners Ltd.

Worcester Street

The creation of Worcester Street in 1822 was promoted by John Phillpotts, a barrister and MP for Gloucester, to replace Hare Lane as the main route into the city centre from the north. The project was funded by tolls collected by the Tewkesbury Turnpike Trust.

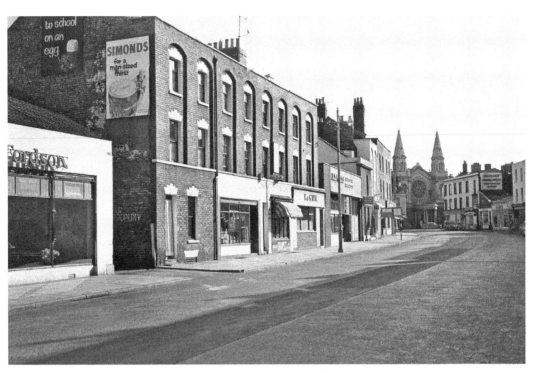

The opening of Worcester Street led to the building of rows of brick and stucco–fronted terraced houses.

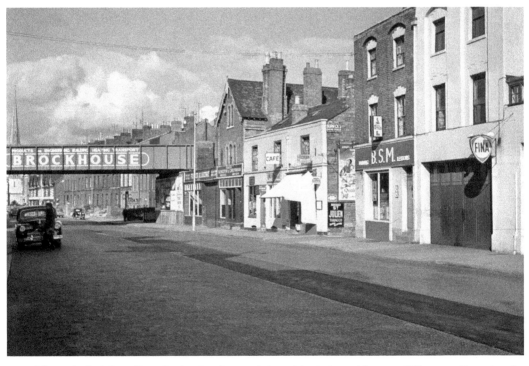

The arrival of the railway in the city disrupted the original planned layout of Worcester Street but the bridges afforded some prominent new advertising spaces.

Southgate Street

Beneath the upper part of Southgate Street lie the extensive remains of the Roman forum. Its south-eastern corner, together with part of the Basilica, was discovered during an archaeological excavation on the site of the demolished Bell Hotel in 1968.

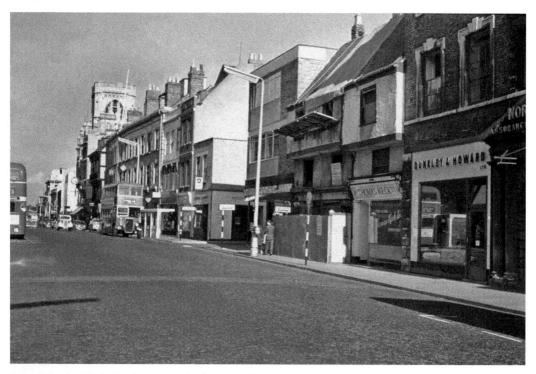

Behind the double-decker bus stands the famous Bell Hotel that traded from the early sixteenth century until 1967. Throughout the centuries the Bell was the premier inn in Gloucester and was the birthplace of the great evangelist George Whitefield in 1714.

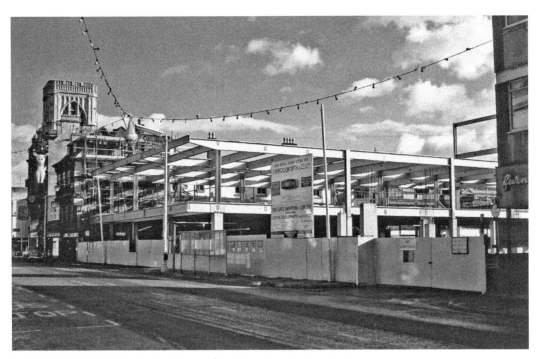

Following the removal of the Bell Hotel construction work began for a large new store for F. W. Woolworth.

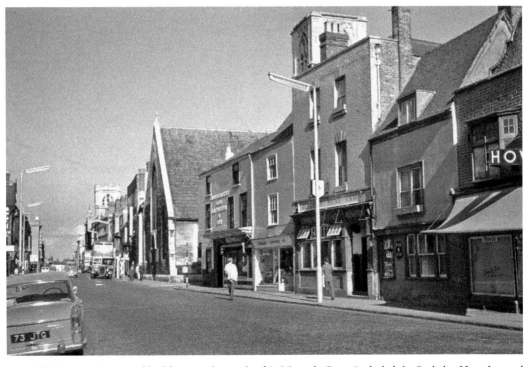

This interesting row of buildings to the south of St Mary de Crypt included the Berkeley Hunt Inn and to the right the long established bakery business of Fry & Son.

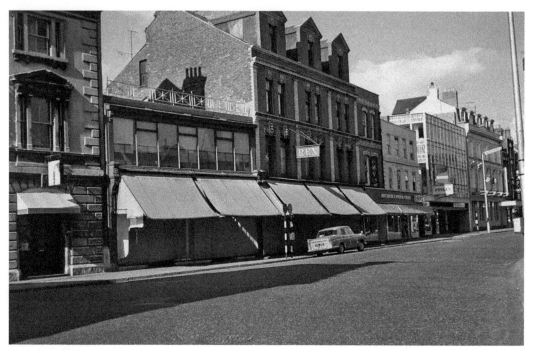

The window displays of Edward Rex's drapery store are well and truly protected from ultra violet light by blinds and awnings. This site is now occupied by the Brunswick Baptist Church.

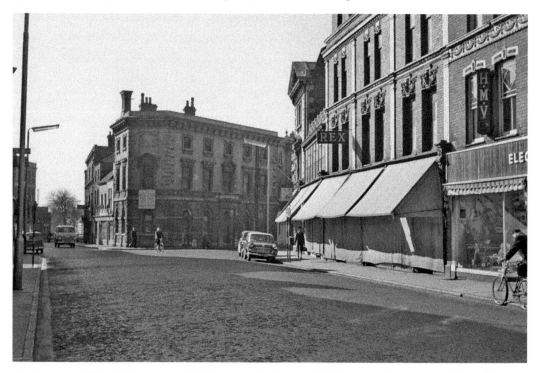

Another view of Rex's drapery store looking towards Commercial Road. On the extreme right is the musical instrument shop of Hickie & Hickie who originated as pianoforte dealers.

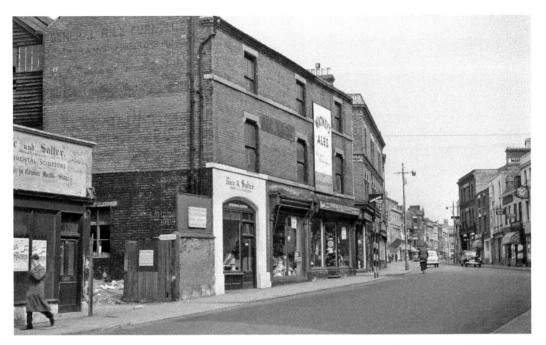

This photograph was taken at the entrance to Parliament Street opposite the premises of Rice & Salter monumental sculptors. Immediately to the right of the building with the advertisement for Watney's Ales can be seen the narrow entry to Kimbrose Lane.

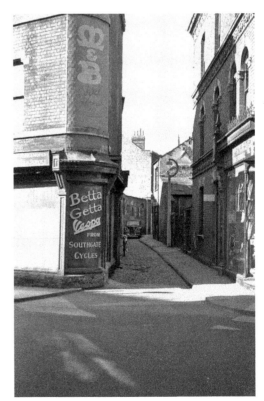

The cobbled Kimbrose Lane led through to Commercial Road. The alignment of the alley at the Southgate Street end marks the position of the chapel dedicated to St Kyneburgh that was built adjacent to the south gate following her death in the Saxon period. The buildings to the right still exist today.

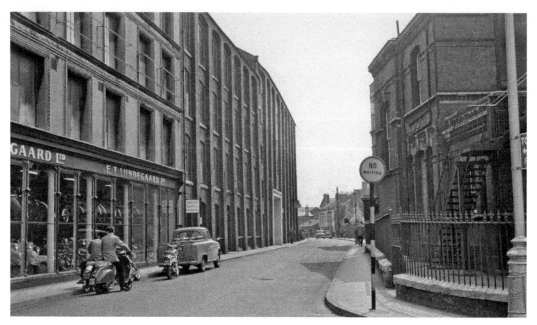

Parliament Street was so named in 1860. It was originally called Green Dragon Lane after an inn of that name that stood facing Southgate Street. The firm of E. T. Lundegaard was a Mecca for motorcycle and scooter enthusiasts for many years. On the right of the street is the Accident and Emergency Department of the Infirmary.

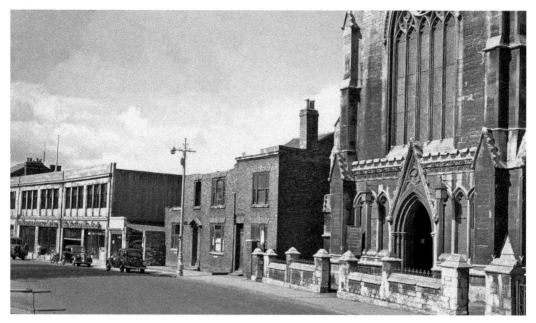

The Southgate Congregational Church was rebuilt and reopened in 1851. The new church was designed with a fourteenth-century style eastern elevation by James Medland. The two houses under removal were immediately replaced by Century Motors, a second-hand car dealership, and beyond are the builder's merchants Western Trading Ltd. The whole of this area is now the car park on the eastern side of the Victoria Basin in the docks.

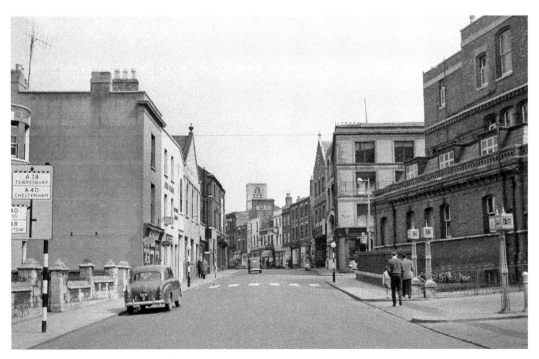

On the right is the entrance to the Royal Infirmary with Parliament Street just beyond. The car in the distance is passing over the site of the medieval south gate.

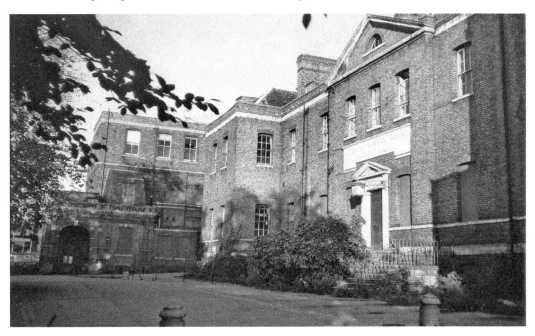

The Gloucestershire Royal Hospital was founded in 1750 and temporarily set up in the Crown and Sceptre Inn in Westgate Street while this building was being designed and erected. It opened here in 1761 and was further enlarged several times in the nineteenth century. It closed in 1975 following the removal of all departments to the new premises in Great Western Road.

Further additions were made to the hospital in 1932 with the building of this detached block alongside Parliament Street. All the buildings associated with the infirmary were taken down in 1984 and replaced by a new office complex initially occupied by the Bank of England.

Among the businesses on the west side of Lower Southgate Street were the showrooms of the builder's merchants Sessions & Sons Ltd and Haine & Corry Ltd with the Barley Mow public house sandwiched in between.

The ashlar-faced building on the right was originally the Albion Hotel that opened in 1831 to provide accommodation for business visitors to the docks.

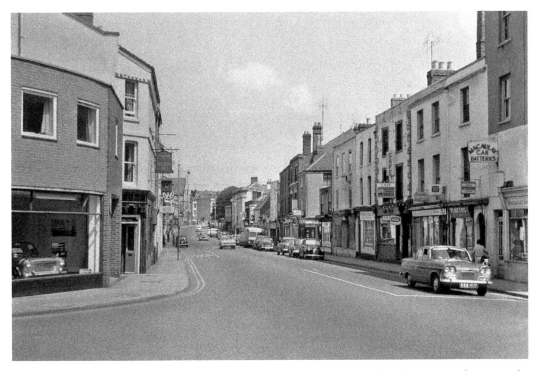

Lower Southgate Street at the junction with Spa and Llanthony Roads. This area was known in the medieval period and later centuries as the village of Littleworth.

Westgate Street

For many centuries this street was probably the busiest and most important thoroughfare in Gloucester as it gave access to the lowest bridge crossing on the River Severn.

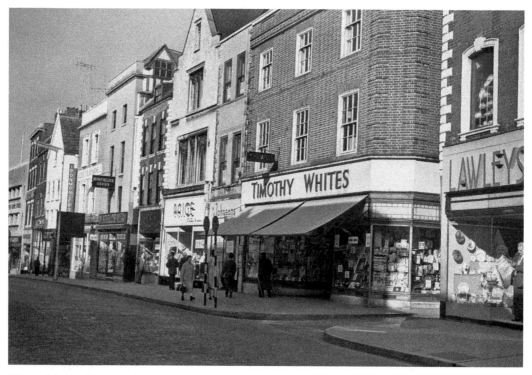

Most of the buildings in this photograph still exist today. Perhaps the most notable absentee is the Gothic style façade occupied by Paige's ladies fashions. The building was erected in 1843 for the National Provincial Bank on the site of the banking house once owned by the famous Jemmy Wood. On the extreme left of the picture, on the corner of College Court, is British Home Stores that later relocated to Eastgate Street. Between Lawleys and Timothy Whites is the entrance to St John's Lane. This narrow entry caused major problems for large delivery vehicles and the damage to the buildings is still evident today.

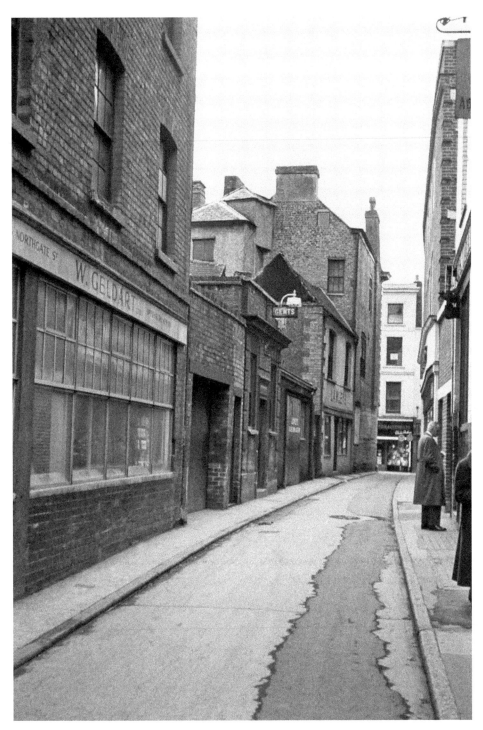

This view of St John's Lane is taken looking towards Westgate Street. The gentleman on the right is looking at photographs on display at *The Citizen* offices. The newspaper was printed here for many years and the presses in the basement could be seen through small windows at pavement level.

The wall in the distance surrounds the burial ground belonging to St John's Church.

A feature within the churchyard was the uppermost part of the spire that was removed from the tower in 1910. When all the burials were removed for the building of Northgate Hall the spire was rebuilt nearby in St Lucy's Garden.

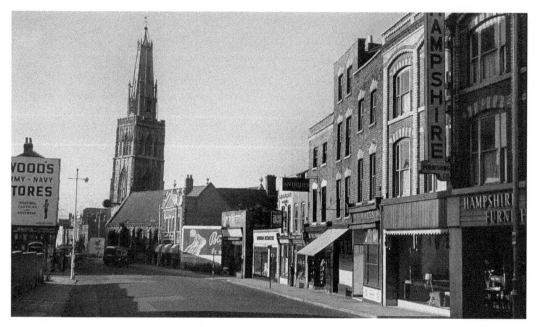

All the buildings on the right down as far as Three Cocks Lane still exist today although in different ownership. The hoarding advertising Bass beer and the little shop to the right occupied the site of the King's Head Inn that was the rival in size and status to the Bell Hotel in Southgate Street. The soldier and the sailor (currently AWOL in this view) painted on the wall of Wood's Army and Navy stores were a familiar landmark for travellers passing through the city to the west.

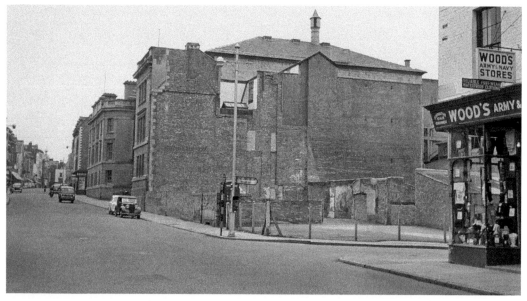

The buildings on the corner of Westgate Street and Upper Quay Street were cleared away in 1957 to make way for an extension to the Shire Hall. The site was previously occupied by the extensive Booth Hall Hotel that had its origins in the medieval period. It was refronted in the eighteenth century with a large pediment containing an armorial shield with two attendant cherubs. These were preserved at the time of demolition and can still be seen today on the corner of Three Cocks Lane.

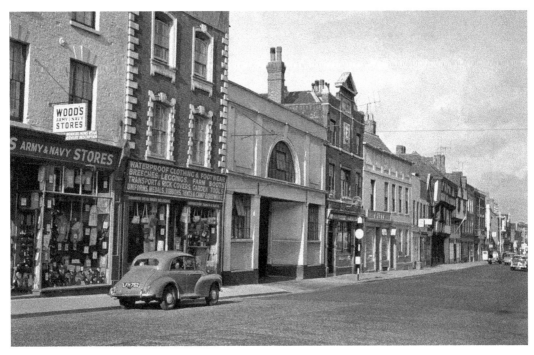

The only street frontage missing today is the white building with a large entranceway with a semi-circular window above. This was the milk distribution depot for the Co-operative Wholesale Society whose premises occupied a large area through to Quay Street.

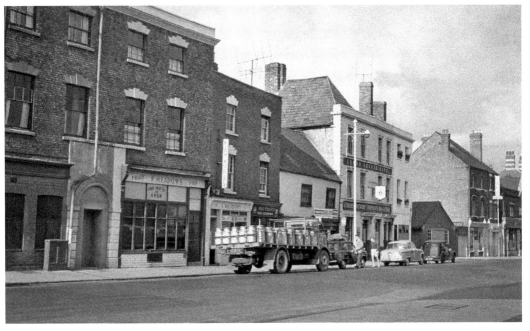

All the buildings down to Lower Quay Street are still with us today including the small two storey property occupied by Keelings newsagents and the much renamed Lower George Hotel. All the buildings west of Lower Quay Street have since been removed and replaced by housing.

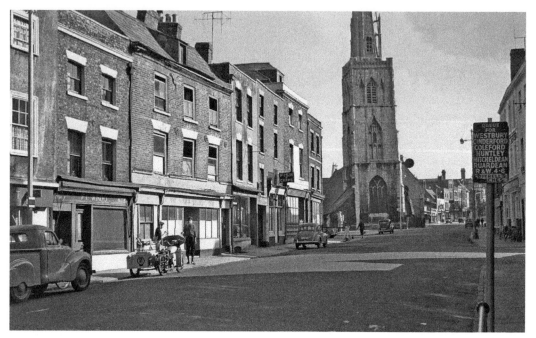

This part of Westgate Street was the point for boarding the Red & White bus service to the Forest of Dean. On the opposite side of the road is the long vanished sight of a motorcycle and side car belonging to an AA patrolman. Just to the left of the base of the tower of St Nicholas church can be glimpsed the controversial family group sculpture that was decapitated on more than one occasion.

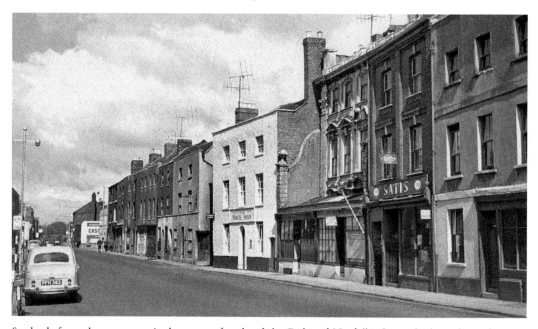

Set back from the pavement is the ornate façade of the Duke of Norfolk's house built in the early eighteenth century. In later years the forecourt was filled with shops and in this photograph it is occupied by P. Veale, gentleman's hairdresser and purveyor of Brylcream. Note the traditional striped barber's pole set at a rakish angle from the shopfront.

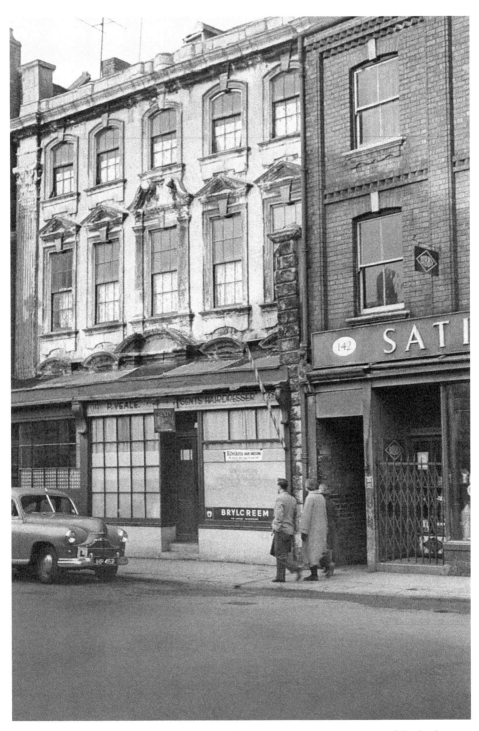

The building was originally known as Eagle House due to a large sculpture of the bird set on the parapet. The house had its own supply of spring water that had certain medicinal properties, this together with a large ornamental garden at the rear led to the establishment of spa here. The house was later occupied by Charles Howard, eleventh Duke of Norfolk.

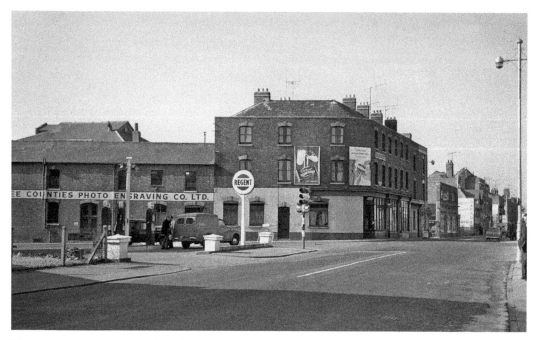

The Regent petrol station stands at the junction of Westgate Street and The Quay. Photo printing blocks used by the local newspaper industry were manufactured by the Gloucester and Three Counties Photo Engraving Company.

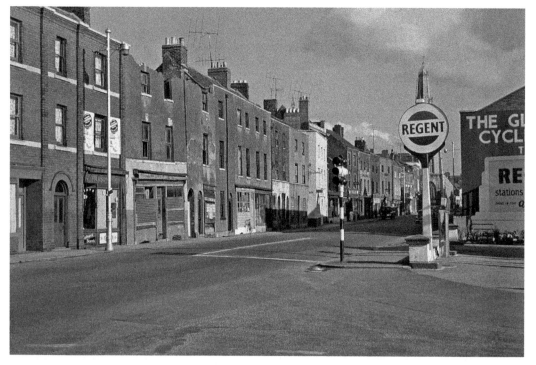

All the houses opposite the Regent sign were removed and replaced by the Dukeries housing scheme and the Lower Westgate car and coach park.

This view is of Priory Road at its junction with Westgate Street opposite the Quay with the Square and Compass Inn on the corner. The road originally looped round along the line of the present St Oswald's Road to the priory ruins. This area is now part of Royal Oak Road.

The northern end of Priory Road looking towards Westgate Street viewed from St Oswald's Road.

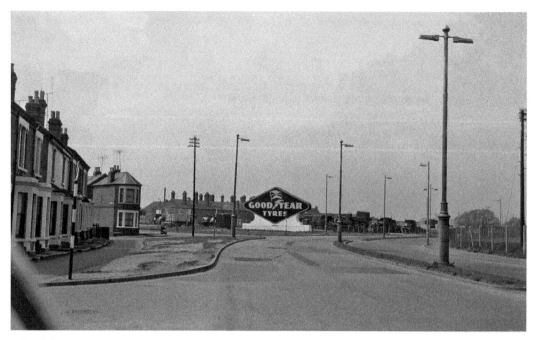

Behind the Good Year tyre advertisement is the Westgate lorry park filled to capacity with military vehicles. The forest of chimney stacks to the left of the lorry park belonged to the St Bartholomew's Almshouses. The first turning on the left is Mount Street with the entrance to Priory Road beyond.

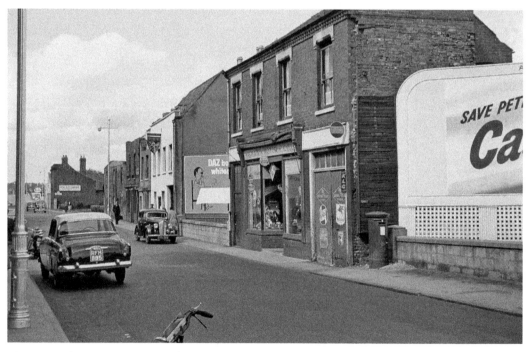

The approach to Westgate Bridge from Priory Road and the Quay passed through an area known historically as The Island. The white building beyond the Daz washing powder advertisement is the Cooper's Arms public house that ceased trading in 1960.

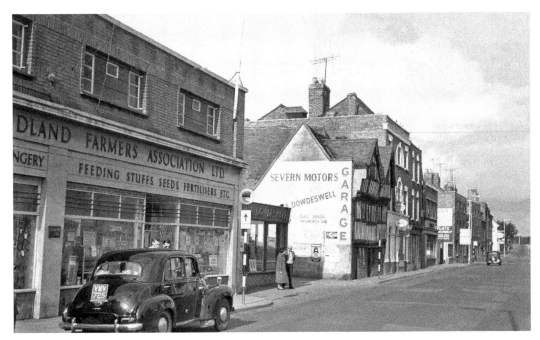

On the corner of the Quay and Lower Westgate Street can be seen the premises of the West Midland Farmers Association who traded in agricultural goods. The whole of this site was redeveloped in more recent years and is now occupied by Countrywide Farmers PLC.

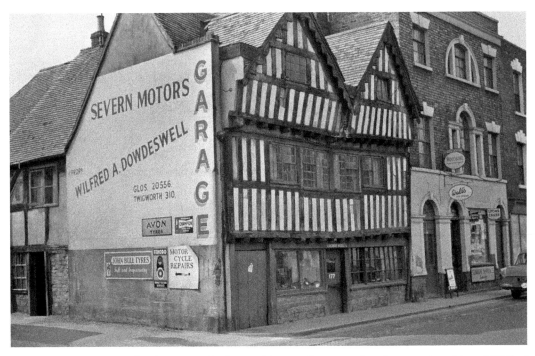

Next to West Midland Farmers is Severn Motors Garage under the proprietorship of Wilfred Dowdeswell. Next door is an interesting medieval-timber-framed building occupied by George Hodson who specialised in selling second-hand car parts.

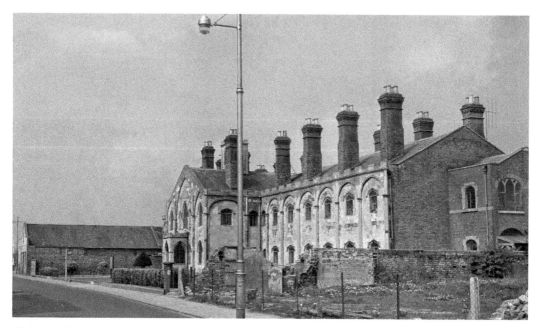

The original St Bartholomew's Hospital was built during the reign of Henry II to house the workers employed on the construction of Westgate Bridge. It became the largest of Gloucester's medieval hospitals and came under the control of the city corporation in the sixteenth century. It was rebuilt at the end of the eighteenth century and remained an almshouse until 1971.

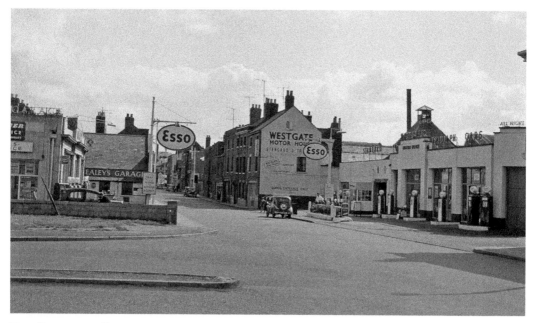

Travellers were well supplied with petrol at the eastern end of Westgate Bridge by the garages of Healey's and the Westgate Motor House. Behind the façade of the latter can be seen the pyramidal roof and tall slender chimney of Williamson's tallow melting factory. These premises were known locally as the 'glue factory' and the appalling smell that emitted from there will last long in the memory of many Gloucestrians.

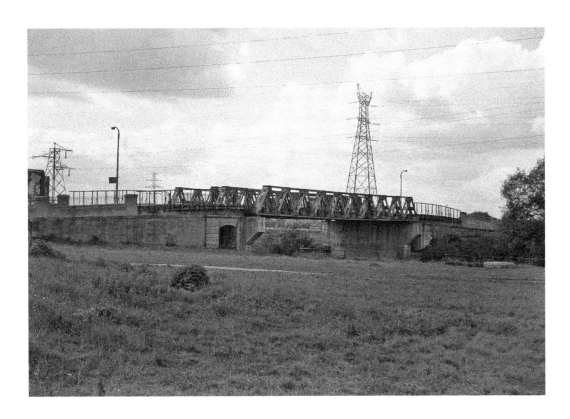

The many arched medieval bridge across the Severn was replaced during 1813–1816 by a single span structure designed by Robert Smirke. Due to the increased weight and volume of traffic generated by the Second World War it was replaced by twin girder bridges set on modified abutments to the earlier bridge. This crossing was again replaced during the construction of the new approach road from the west in the early 1970s.

To the West and North of the Cathedral

St Mary's Square evolved around the churchyard of St Mary de Lode, reputedly the oldest parish church in the city. The memorial to Bishop John Hooper marks the site of his martyrdom by fire in 1555. Most of the houses on the north and south sides of the square were demolished in the late 1950s and early 1960s.

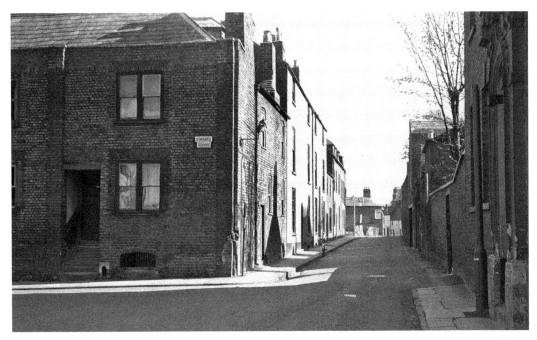

At the end of this row of houses in St Mary's Street once stood Pateshall Alley and St Mary's Hall. The hall was demolished prior to 1958 when it was replaced by a new building for an independent church that now stands almost opposite Pitt Street.

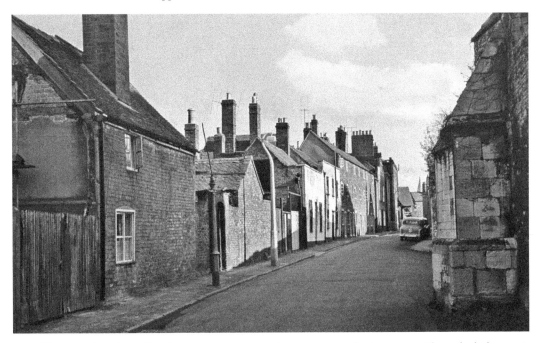

Pitt Street has changed little since this photograph was taken in the late 1950s. The cathedral mason's yard now occupies an area on the left-hand side of the street. It seems that the local authority embarked on a programme of replacing the old lamp posts with new concrete standards at the time this view was taken. The old cast-iron post and feed pipe are awaiting removal.

This view shows the southern end of St Catherine Street at the junction with St Mary's Street to the right and Priory Road to the left. The little single-storey building on the left was Blundell's Forge that manufactured all sorts of ironwork and also produced its own range of bicycles for a few years.

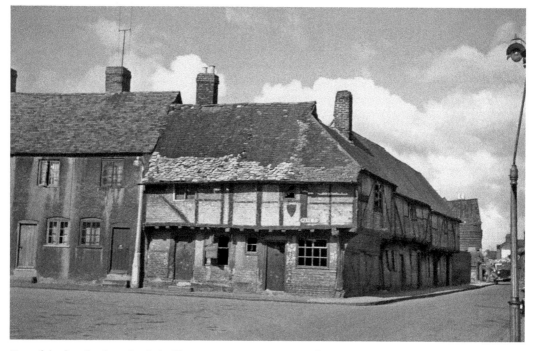

One of the first Sunday schools in Gloucester was set up in a small cottage halfway along the south side of St Catherine Street in 1780. The building on the corner of St Catherine Street and Park Street bears a small shield that claimed it too was a Sunday school but for girls only.

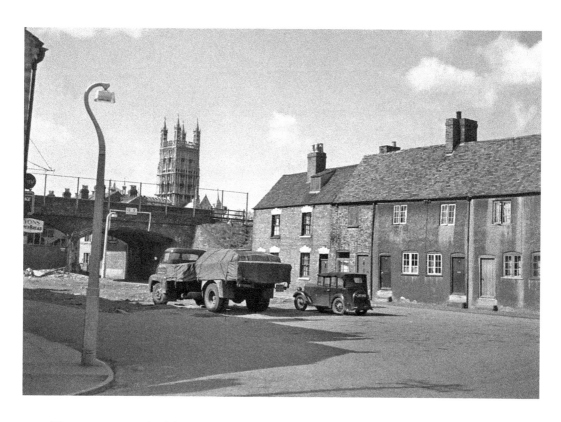

The open space north of the railway bridge between Park Street and Hare Lane is called The Knap. The original area extended from St Catherine Street to where the car and lorry are parked. The car parking area was further extended following the demolition of a small row of cottages that stood in front of the railway bridge.

The Quay Area

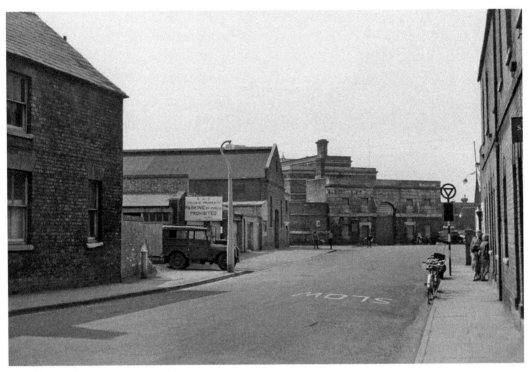

Upper Quay Street was originally known as Castle Lane as it gave access to the main gate of the medieval castle from Westgate Street. The last remaining parts of the castle were taken down in the late eighteenth century and replaced by a new county gaol that opened in 1791. The gabled building on the left was the Gloucestershire County Council's central repair depot where vehicles and plant machinery were serviced and repaired.

Numbers 4–10 Quay Street occupied the area that is now part of the Gloucester Life Museum premises.

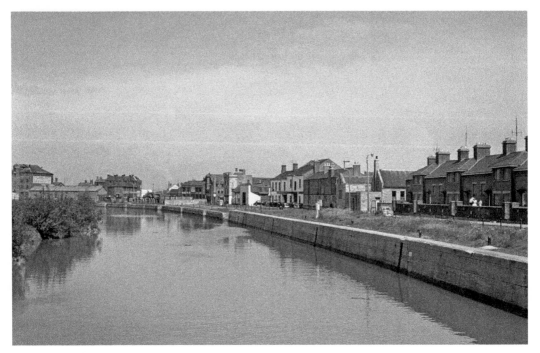

The Old Custom House at the far end of the Quay is the only building in this view that survives to this day. On the right are houses built in 1921 for officers employed at HMP Gloucester. These homes were later removed and a new extension to the gaol built on the site in the 1980s.

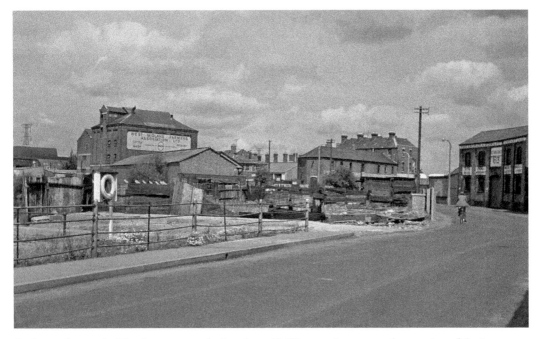

At the northern end of the Quay near to the junction with Westgate Street were the premises of the Iron and Hardware Company, who claimed to have been founded in the year 1615, and the West Midland Farmers Association.

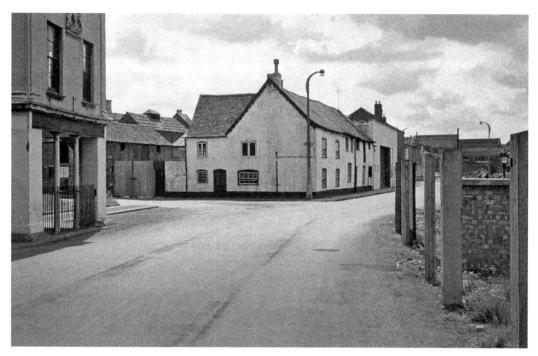

On the southern corner of Quay Street is the gable end of the Mermaid Inn. The inn served the river trade from the eighteenth century as a depot and warehouse for goods destined for places upriver.

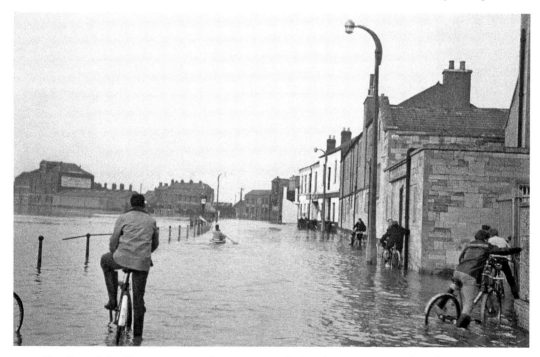

Flooding of the Quay was a regular occurrence during the winter time. This always proved to be challenge and a source of enjoyment to younger cyclists and to the more mature canoeists. To the left and slightly above the canoeist is the sign for the Ship Inn with a model galleon on top.

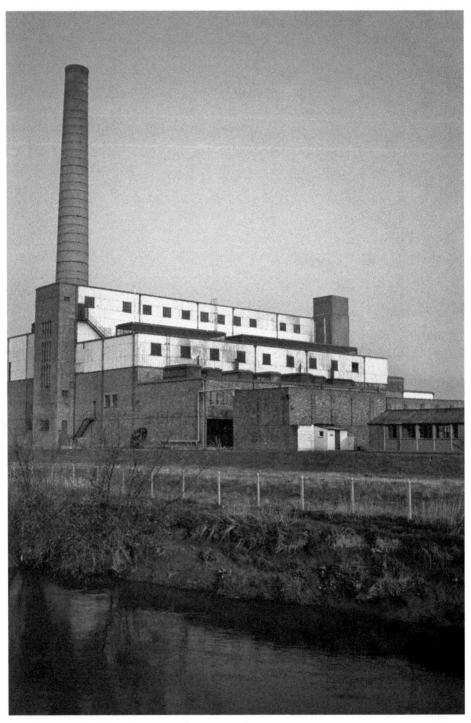

On the west side of the river opposite the southern end of the Quay stood the Castle Meads power station. This coal-fired station was constructed in 1943 to provide extra supplies to the national grid. Coal was delivered via a branch railway line across Alney Island and other deliveries were made by boat to a jetty opposite the lock into the docks.

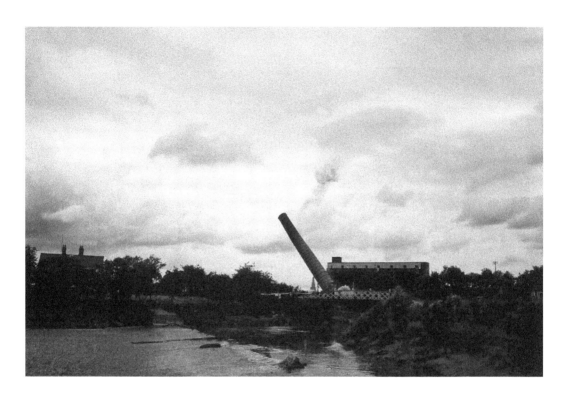

The power station ceased to generate electricity in 1970 and the great chimney expelled its final puff of soot in 1978. This atmospheric photograph was taken from the east bank of the river at Llanthony weir.

Away from the City Centre

This tranquil scene was captured in Robinson Road at its junction with Central Road. The roads at that time were very cyclist friendly and provided ample parking for the motorist.

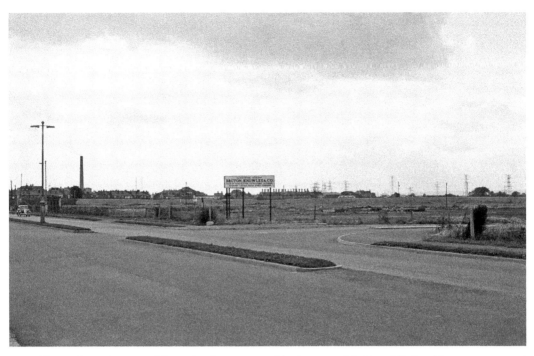

The cattle market moved from the city centre to this site west of St Oswald's Road between 1955 and 1958. The site is now occupied by a Tesco supermarket and the St Oswald's retail park.

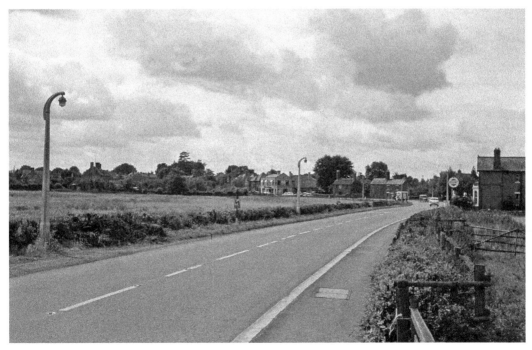

This view of the Tewkesbury Road at Longford was dramatically altered by the building of a roundabout for the outer northern bypass that opened in 1983. In the distance is the Longford Inn and to the left is the area now occupied by Plock Court playing fields.

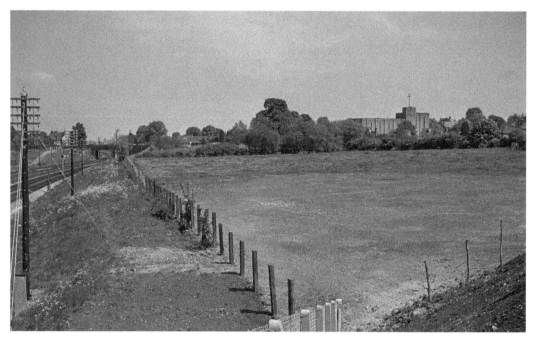

St Barnabas Church was consecrated in 1940. It replaced a temporary timber and asbestos church built in 1922 on the western side of Stroud Road. The photograph was taken during the construction of Cole Avenue at the approach to the new bridge across the railway. The meadow in the foreground is now occupied by the houses in St Barnabas Close.

Whaddon School was built at the junction of the present Grange Road and Stroud Road in 1908. The provision of street lighting is in progress along the main road ahead of the new housing development that was built north of the school.

Christmas Festivities at Gloucester in the Early 1930s

The images in this final section were not taken by John Rowden but formed part of his collection of family photographs. These here feature the regular Christmas attractions sponsored by Blinkhorns Department Store and came into his possession through his father-in-law Ernest Russell who was manager of the bedding department for many years.

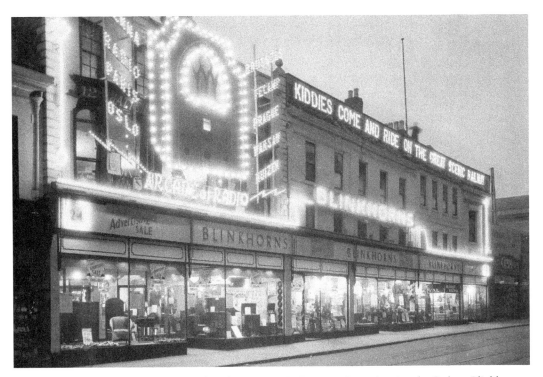

Blinkhorns store began as a modest shop set up in Eastgate Street in 1843 by Robert Blinkhorn, a linen draper from Maidstone. He was described as "ever a shrewd and successful businessman" who expanded the shop into a large department store. Due to the competition from the major chain stores the firm ceased trading in 1955 and the property was sold to F. W. Woolworth and Co.

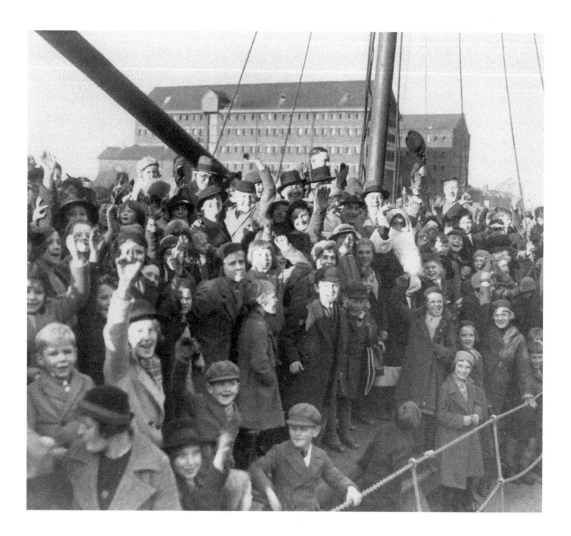

Blinkhorns' Christmas promotions began with the arrival of Father Christmas by boat near Llanthony Bridge. The vessel acquired a distinct list to starboard with all the young passengers clamouring to be in the photograph. Ernest Russell is the second gentleman to the left of Father Christmas.

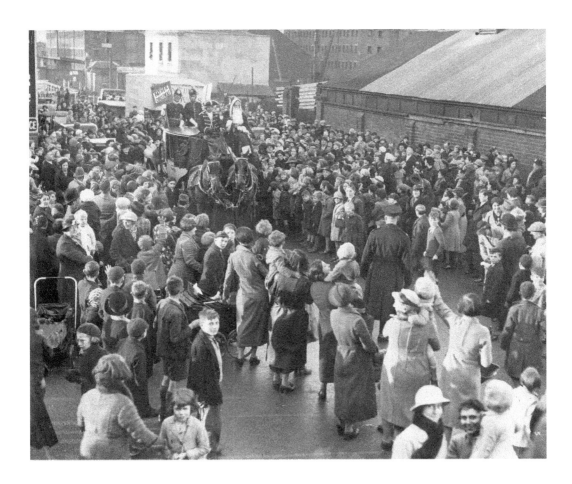

Once safely on the quayside Father Christmas boards a horse-drawn coach with one of the carriage attendants carrying a placard nominating Blinkhorns as their destination.

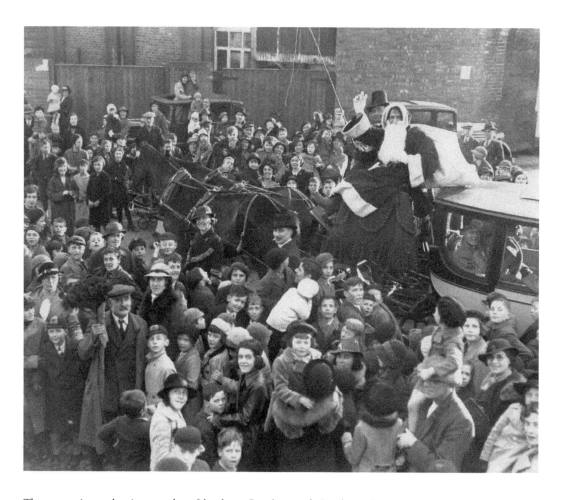

The procession makes its way along Llanthony Road towards Southgate Street.

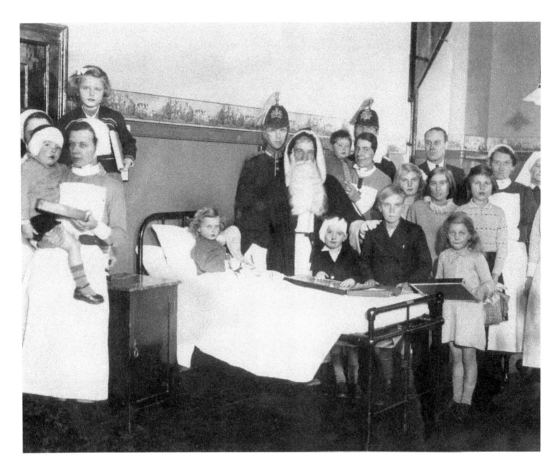

On his way to Eastgate Street Santa made a stop at the children's ward of Gloucester Royal Infirmary in Southgate Street to distribute presents to a subdued gathering of children and staff.

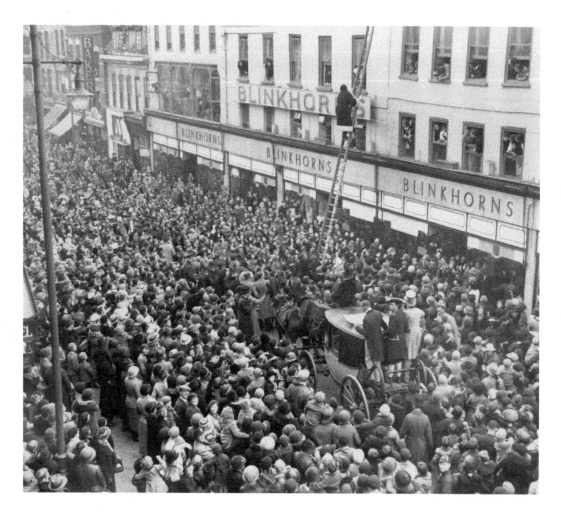

On arrival at the store the coach is greeted by a massive crowd of spectators who watch with anticipation as Father Christmas ascends a ladder to the top of the building. The extra-long ladder was provided by Wood and Pimm, painters and decorators, based in Wellington Street. It is not possible to estimate the total number of onlookers but there are well over 1,000 in this photograph alone. Several members of the Gloucester Constabulary are in evidence but there is no sign of the Health and Safety Officer or the risk assessment forms.